WHITE HOUSE NEWS PHOTOGRAPHERS' BEST

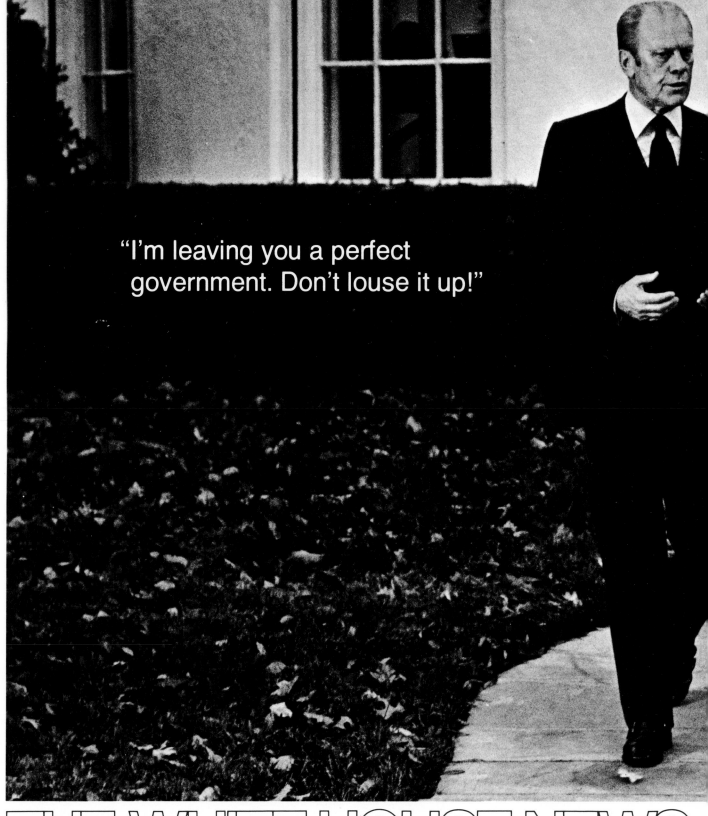

"I'm leaving you a perfect government. Don't louse it up!"

THE WHITE HOUSE NEWS

ACROPOLIS BOOKS, LTD
Washington, DC 20009

Foreword by President Jimmy Carter

**Introduction by Bob Cirace, President, White House News
Photographers Association**

Edited by Beverly Jackson

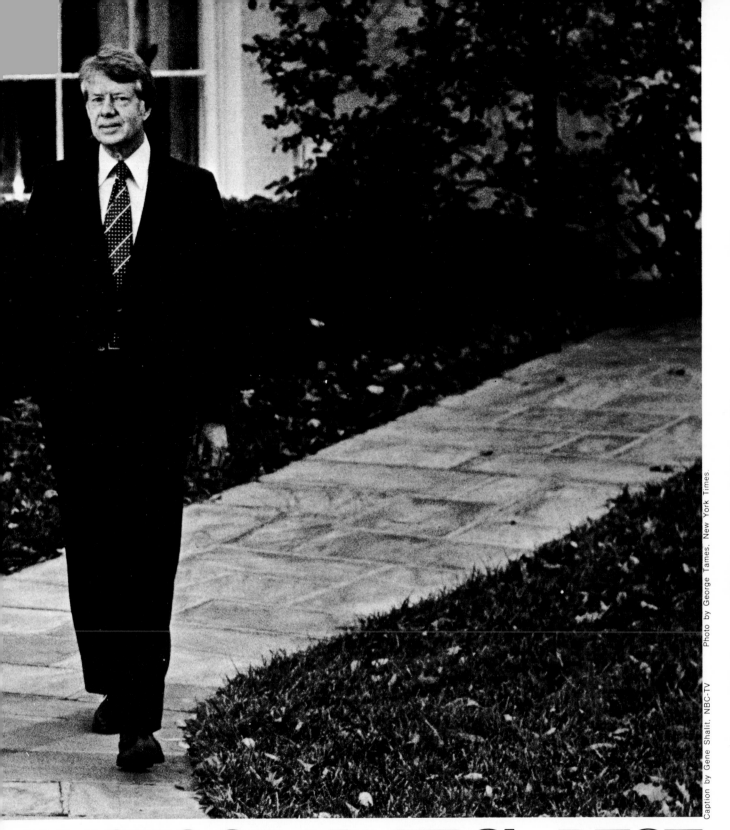

Caption by Gene Shalit, NBC-TV

Photo by George Tames, New York Times.

PHOTOGRAPHERS' BEST

Contributors:

HOWARD H. BAKER, JR.
U.S. Senator

ART BUCHWALD
Syndicated Columnist

BARRY GOLDWATER
U.S. Senator

DAVID HABERSTICH
Curator of Photographs
National Museum of History
and Technology
Smithsonian Institution

JERALD C. MADDOX
Curator of Photography
the Library of Congress

PAT OLIPHANT
Political Cartoonist
The Washington Star

NELSON ROCKEFELLER

GENE SHALIT
NBC-TV

LINDA WHEELER
Staff Photographer
The Washington Post

First published in the United States by
Acropolis Books Ltd.
Colortone Building, 2400 17th St., N.W.
Washington, D.C. 20009

Printed in the United States by
Colortone Press, Creative Graphics Inc.
Washington, D.C. 20009

Library of Congress Cataloging in Publication Data
Main entry under title:

The White House news photographers best.

 1. Photography, Journalistic. 2. White House News Photographers
Association. I. Jackson, Beverly, 1942-
TR820.W44 779'.0973 77-13227
ISBN 0-87491-191-5

A Message From The WHNPA President

In view of the technological developments of our times, it is interesting to note that the mechanical aspects of the photographic process have become less important.

One hundred years ago, a photographer coated his own photographic plates, and had to do his own processing.

Today the wide variety of lightweight, plastic films are created, coated and processed by machines in minutes. The operation of lenses and lighting has been automated in a similiar manner.

The real art of photography lies in capturing the photographic instant just as an artist captures the essence of a scene on canvas. This book attempts to emphasize those artistic aspects of photography, and in so doing, gain some insight into the thoughts and emotions of the photographers who created those images on film.

This could easily be a "how-to" book of techniques, but it is, foremost, a book of art.

Bob Cirace

Bob Cirace,
Freelance Newsfilm Photographer.
President,
White House News
Photographers Association.

"Wild Ponies of Assateague"
Jim Stanfield
National Geographic

Contents

Winners

A Message From The President Of The United States

Although a newcomer to the White House, I am well acquainted with the work of the White House News Photographers Association and its important role in writing a pictorial history of the Presidency.

Your good humor, patience, ingenuity and professionalism have always impressed me—especially on those 16-hour days when you were left in the rain waiting for me and those times when you wore your arms out brushing away the gnats in Plains.

In the coming years, we will spend many hours and days together. I look forward to these times and, along with Rosalynn and the rest of the family, want to thank you in advance for mirroring these experiences of ours for the American public.

I wish you the best for 1977—and a good picture every time.

Jimmy Carter

An Inside Look At Last Year

GENE SHALIT

"Oh Thigh Can You Thee."

Photo by Charles Tasnadi. Associated Press

Photo by Teresa Zabala. New York Times

"Let's See Now, Was I Putting It On Or Taking It Off?"

Gene Shalit
NBC-TV

"My Dad's In Favor Of Bussing."

"Hey, Look . . . There's Mark Eden."

Photo by John Duricka, Associated Press.

Photo by Frank Johnston, Washington Post.

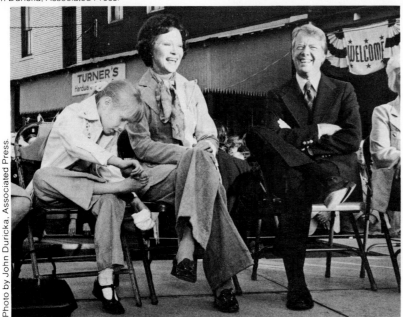

Photo by John Duricka, Associated Press.

Photo by Francis Routt, Washington Star.

"I'll Go Adlai Stevenson One Better."

"A Little Birdie Told Me."

News Film Photographer Of The Year

Paul Fine
WMAL-TV

Paul Fine, probably Washington's most honored cinematographer, and a native of the Nation's Capitol, is more than just a film producer for the WMAL-TV documentary team. Paul is also producer-director of many of the television films which have won him an impressive string of awards, including nine Emmies and the title of Newsfilm Photographer of the Year three out of the last four years.

Paul grew up in a family where his father Nate was the photographer for the Washington Redskins, and also an active member in the White House News Photographers Association. After three years at Byron Motion Picture Labs in Washington, Paul joined WMAL-TV as a news cameraman in 1969, at the age of 23. His creativity on news assignments led to a transfer to public affairs in 1972.

Although he has been the focus of international attention for his cinematographic skills over the years, Paul points out "The other people on our team figure into everything I do, because I don't think in this business, or any business, there's one particular individual who can make it all by himself. Somehow, the cinematographer gets a lot of glory . . . other people's hard work isn't seen. It takes a good producer/director, a good editor, and, as everybody around here knows, it takes people working together to make it come together."

Award
Kodak Pageant 126-TR 16mm. Sound Projector
Courtesy, Eastman Kodak

Day/Date Wrist Watch
Courtesy Hamilton Watch Co.

Gift Certificate
From WMAL-TV,
WRC-TV, and
WTOP-TV.

Documentary Class

An Award for Best Documentary Film or
Videotape

PAUL FINE,
WMAL-TV

Paul Fine and crew covered more than
30 fires during the four months they
literally lived with members of the
D. C. Fire Department to make this half
hour documentary film. However, the
purpose of the special program was to
show the typical life of our city's fire
fighters and not the fires themselves . . .
their off hours, the quiet times as well
as the danger and excitement.

In preparation for the assignment,
Paul and Clyde Roller (winner of the
Sound Division) went through a day
long training program. They wore gas
masks, and standard regulation fireman's
uniforms, and were taught to run up and
down stairs blindfolded carrying their
equipment.

The film, which originally aired on
WMAL-TV in December, 1976, has also
won the coveted Gold Waffle as best
film of the year at the Washington Film
Festival, and the prestigious Gold
Medal from the Virgin Islands Interna-
tional Film Festival.

First Prize
"We're no Heroes"
Paul Fine
WMAL-TV

Second Prize
"Ole Belle Reed"
Bob Boyer, WTOP-TV

Third Prize
"Welcome To The World"
Steve Affens, WMAL-TV

Award
$210 gift certificate
Courtesy, Brenner Cine-Sound and
Cinema Products Corporation

Rolex Oyster Perpetual Date, Reference
1500 Steel Chronometer, with matching
steel bracelet
Courtesy, Rolex Watch Corporation

Vivitar Model 604 Point'n Shoot Pocket
Camera Kit, Courtesy, Ponder & Best
Corporation

Gift Certificate
From WMAL-TV,
WRC-TV, and
WTOP-TV.

Personalities Class

A Feature on an Individual

Sound Class

An Award for Best Sound Reproduction

PAUL FINE,
WMAL-TV

This assignment started out as an idea for following an FBI agent through one day's training at their special facility in Quantico, Virginia. But, when Paul and crew arrived, they discovered Laura Sullivan and two other women in the class of about 50 agents in training and decided to concentrate on her.

The day included boxing, an obstacle course consisting of the usual mud, ropes, and wall-climbing, as well as, a two mile run. Paul and camera participated in everything in order to make the film.

Award
$210 gift certificate
Courtesy, Brenner Cine-Sound and Cinema Products Corporation

Rolex Oyster Perpetual Date, Reference 1500 Steel Chronometer, with matching steel bracelet
Courtesy, Rolex Watch Corporation

Gift Certificate
From WMAL-TV,
WRC-TV, and
WTOP-TV.

First Prize
"Laura Sullivan-FBI Agent"
Paul Fine
WMAL-TV

Second Prize
"Composed Composer"
Paul Fine, WMAL-TV

Third Prize
"This Is Making It"
Pete Hakel, WMAL-TV

CLYDE ROLLER,
WMAL-TV

Clyde Roller and Paul Fine teamed up again in 1976 to make the award-winning real-life look at the world of the firefighters in the Nation's Capitol. The two WMAL-TV award-winners spent more than four months with Engine Company 16, Truck Company 3, to get the footage they needed for this outstanding film.

There were enormous challenges to their technical ability since the equipment had to be protected with special covers against both fire and water. For Clyde, the background generator noises were an additional handicap while interviewing the firemen who narrated the story themselves.

Clyde began his Washington career as a WMAL radio engineer eventually moving to WMAL-TV as studio cameraman and sound man for news and documentary crews. His outstanding sound engineering has earned him numerous local Emmies, prizes from the WHNPA, and top honors at the Virgin Islands International Film Festival four years running.

Award
CL425 New Shotgun Condensor Microphone System
Courtesy, Electro-Voice

Rolex Oyster Perpetual Date, Reference 1500 Steel, Chronometer, with matching steel bracelet
Courtesy, Rolex Watch Corporation

Gift Certificate
From WMAL-TV,
WRC-TV, and
WTOP-TV.

Editing Class

An Award for Best Film or Videotape Editing.

First Prize
"We're no Heroes"
Clyde Roller
WMAL-TV

Second Prize
"They Walk Alone"
John Lureau, WMAL-TV

Third Prize
"Cattle Auction"
Clyde Roller, WMAL-TV

GORDON SWENSON,
NBC-TV

After 11 years as a film editor with WTTG-TV and TVN, Gordon started a freelance assignment for NBC-TV in the summer of 1975, which continued for nearly two years. During that time, he edited numerous features and specials for the "Today Show" and the "NBC Nightly News."

The award-winning piece about the early 1976 Presidential campaign included material about the seven Democrats competing in the New Hampshire primaries. Together with newsman Tom Petit, Gordon came up with a spectacular five minute piece which appeared on John Chancellor's "Nightly News."

Award
16mm. Refisquick Tape Splicer with Diagonal Serrated Splicer
Courtesy General Enterprizes Corporation

Rolex Oyster Perpetual Date, Reference 1500 Steel, Chronometer, with matching steel bracelet
Courtesy, Rolex Watch Corporation

Gift Certificate
From WMAL-TV,
WRC-TV, and
WTOP-TV.

First Prize
"New Hampshire Democrats"
Gordon Swenson, NBC

Second Place
"Udall Profile"
Robert Mole, NBC

Third Prize
"Ole Belle Reed"
Bob Boyer, WTOP-TV

Feature Class

Non-news Subjects of
Extended Length

Spot News Class

Unscheduled News Events

PETE HAKEL,
WMAL-TV

This special feature piece about the men who guard the Tomb of the Unknown Soldier was filmed from 3 AM to dawn on one of the coldest days in January 1976. It wasn't a holiday or a special event, but just a typical segment in the life of the members of the U. S. Army's Old Guard. Pete spent five hours in the solitude of Arlington Cemetary to come up with this award-winning piece.

Pete's awards this year are by no means his first. In 1975 and 1976, he received prizes from WHNPA and has also been a multi-Emmy winner, including two in this year's competition. He has been with WMAL-TV since 1969. Prior to that, he worked as a motion picture photographer with the United States Coast Guard, filming search and rescue missions in the South Pacific.

Award
$210 gift certificate
Courtesy, Brenner Cine-Sound and
Cinema Products Corporation

Rolex Oyster Perpetual Date, Reference 1500 Steel Chronometer, with matching steel bracelet
Courtesy, Rolex Watch Corporation

Gift Certificate
From WMAL-TV,
WRC-TV, and
WTOP-TV.

First Prize
"They Walk Alone"
Pete Hakel, WMAL-TV

Second Prize
"Metro—Long Time Coming"
Paul Fine, WMAL-TV

Third Prize
"Celebrate America"
Paul Fine, WMAL-TV

Honorable Mention
"Paramedics In Need"
Paul Fine, WMAL-TV

HAROLD HOILAND,
WTOP-TV

Hal Hoiland never suspected when he grabbed his camera to cover an overturned truck on the Capitol Beltway one summer day in 1976 that he would end up filming a cattle round-up. More than 40 head of prime beef, including one stray calf, were being protected from the traffic by a corral of trucks and cars. One Montgomery County policeman covering the accident told Hal, "I sure never learned cattle rustling at the police academy!"

Hal began his career in 1960 with WXEX-TV in Petersburg, Virginia. From there he moved on to WMAR-TV, Baltimore, and within two years joined WBAL-TV where he was awarded the city's top cameraman's honors in 1964. With WTOP-TV since 1966, Hal was selected Newsfilm Photographer of the Year by WHNPA in 1974.

Award
$210 gift certificate
Courtesy, Brenner Cine-Sound and
Cinema Products Corporation

Rolex Oyster Perpetual Date, Reference 1500 Steel Chronometer, with matching steel bracelet
Courtesy, Rolex Watch Corporation

Miller Universal Tripod and Head
Courtesy. Cinema Products Corporation

General And Day Feature Class

Scheduled News Events or
Features Shot in One Day

First Prize
"Cattle Rustle"
Hal Hoiland
WTOP-TV

Second Prize
"Preterm Takeover"
Dave Moubray, WTOP-TV

Third Prize
"Hostages"
George Fridrich, NBC

Gift Certificate
From WMAL-TV,
WRC-TV, and
WTOP-TV.

CHUCK FEKETE,
NBC-TV

"Children's Express," a four minute
segment about a children's news gather-
ing organization at the Republican
Nominating Convention in Kansas City,
is the first videotape to win a prize from
the White House News Photographers
Association.

With newsman Jack Perkins, Chuck
spent one day covering the activities
of about 15 children ranging from 8-12
years who produced a newspaper at
the convention.

Chuck is no stranger to the WHNPA
awards scene, having won prizes in
nearly every newsfilm category since
1968. In addition, he has received
Emmys and awards from the National
Press Photographers Association. Before
joining NBC about 10 years ago, he
was a U. S. Air Force photographer
for nine years.

First Prize
"Children's Express"
Chuck Fekete, NBC

Second Prize
"Grape Stomping"
Harold Hoiland, WTOP-TV

Third Prize
"Kansas City"
Chuck Fekete, NBC

Award
$210 gift certificate
Courtesy, Brenner Cine-Sound and
Cinema Products Corporation

Rolex Oyster Perpetual Date, Reference
1500 Steel Chronometer, with matching
steel bracelet
Courtesy, Rolex Watch Corporation

Gift Certificate
From WMAL-TV,
WRC-TV, and
WTOP-TV.

Assignment: Melinda Darnell, A 15 Year Old Girl Dying Of Brain Cancer

BERNIE BOSTON,
The WASHINGTON STAR

Assignment Melinda Darnell, a 15-year-old girl dying of brain cancer.

That's what the pink assignment slip read when it was handed to me early one October afternoon by the reporter, Mary Ann Kuhn, who was assigned to write the story. Melinda's family had consented to have a photographer and reporter invade their home and lives to tell how they were coping with death. We would become a part of their lives.

A news photographer dreams of the kind of story which can be fully developed, and which will be well-displayed by his publication. This one had all those elements, but with a difference. I knew from the beginning it would be a tragic and tender story, one with a very predictable, sad ending.

The first order of business was to meet the Darnell family, and especially Melinda, who had been described to me as a beautiful fifteen-year-old blonde.

The tumor had been discovered over three years ago, and she had only a few more weeks, maybe months, to live. On the way to the Darnell apartment, the reporter filled me in on as much of the family as she had learned. But my thoughts were on how I would enter this home as a prying photographer, a stranger, and yet record on film the hours and days of the family's private life.

I knew I would be there for their happy moments as well as their sad ones, and that those sad moments would surely come. The afternoon of that first meeting was spent getting acquainted with Melinda, her parents, and two sisters.

It was important to me, and to the story,

that I become part of their lives. Only in this way would they be so at ease with me and my camera that I could capture the moments in their lives as they truly were. And yet I had to remain far enough removed as to not let the sadness of watching this young life come to an end affect the way I would tell the story. Our readers should see a true portrayal of how Melinda and her family faced death and how it affected their lives.

This was a real contradiction. I could not help but become friends with each member of the family. After many working hours as well as off hours spent with Melinda, she began to regard the camera as a part of me. We became close enough that she no longer really saw it, and I was able to record her life as it ran out before me.

Melinda's last two months were spent

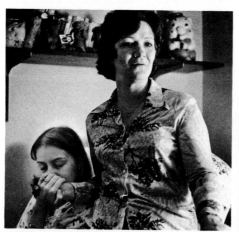

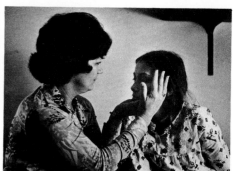

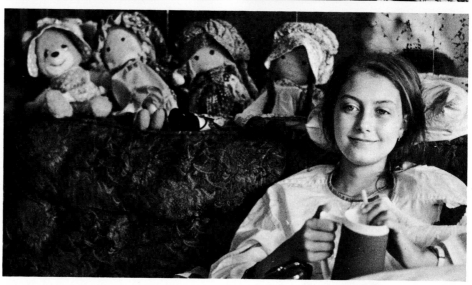

in preparation for Thanksgiving and Christmas. She wanted to give those close to her gifts, sort of going away presents, she said. So we went shopping as a family . . . Mom, Dad, the reporter, the camera, and me. These were the happy days for Melinda, but the saddest for those of us around her because we weren't sure she would live to see the day she was so looking forward to . . . Christmas.

Late one night a week before Christmas, I was called to come to the Darnell's home. Melinda had taken a turn for the worse. She was rushed to the hospital. The end of the story was near, and photographing her brief life became more and more difficult.

I wanted to show our readers what she

was going through, but her pain was too personal to photograph. I tried to show instead the silent communications, the tender feelings shared by Melinda and her family.

Christmas was everything to Melinda, and her doctors allowed her to go home for the day. To all of us this was the happiest day—Melinda with her family sharing gifts and a special kind of fondness. To me it meant the most sensitive picture, the one that best tells Melinda's story. She is lying down, all bundled up with eyes wide and bright, and the faintest smile breaking on her lips. Her mother is holding a Christmas

gift, radio headphones, to her ears.

She went back to the hospital that night, and died New Year's Day. Yes, I had become involved. I could not photograph the last moments. It was not important. What was important was this young life that had entered mine, and the family that had become my friends.

The story ended with the funeral and burial in West Virginia. The only pictures were taken from a distance. I could not let the camera destroy Melinda's last day.

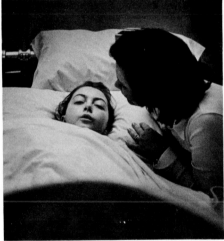

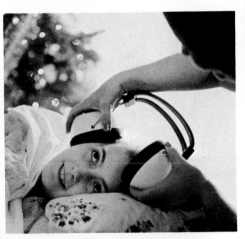

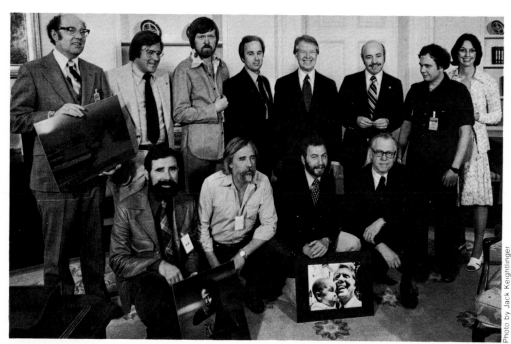

President Carter with 1977 Award Winners, March 31, 1977, the White House

Photo by Jack Keightlinger

Still Photographer Of The Year

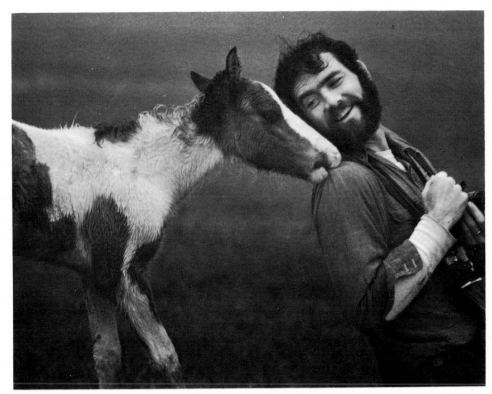

Jim Stanfield
NATIONAL GEOGRAPHIC

Jim Stanfield has been with the National Geographic since 1967 and worked previously with Black Star. He was born into a family of newspaper photographers in Milwaukee and started his career with his hometown paper, the Milwaukee Journal.

A graduate of the University of Wisconsin and Layton School of Art, Jim has been the recipient of many photo awards over the past 15 years. These have included Military Photographer of the Year in 1962, LOOK Magazine Sports Grand Award in 1963-64 and the Donald T. Wright Award for Journalism in Maritime Transportation in 1972.

He was also named the White House News Photographer of the Year in 1970 and had photos exhibited in "Photography in the Fine Arts" at the Metropolitan Museum of Art, New York City, in 1967. National Geographic assignments have taken him all around the world, but this photo of Jim was taken near home while shooting *Wild Ponies of Assateague.*

Grand Award

Contact RTS Camera
50mm f1.4 lens
25mm f2.8 lens
200mm f3.5 lens
Power Winder
Fitted Case Courtesy Yashica, Inc.
Contax Division

Day/Date Wrist Watch
Courtesy Hamilton Watch Co.

Presidential Class

Photograph showing the President
of the United States.

Teresa Zabala
NEW YORK TIMES

Teresa Zabala travelled with the Ford
team eight of the last ten days of the
1976 campaign, right up to Grand
Rapids, far into election night. She was
off for four hours to rest and then back
into the White House Press Room to
cover Ford's concession speech the next
morning. "We were crammed in like
sardines. It was a lucky shot," she
recalls, thinking back to November 8,
1976.

Teresa has been with the NEW YORK
TIMES for three years, having photo-
graphed previously for the MONTEREY
PENINSULA HERALD, BOSTON RECORD
AMERICAN and the SAN FRANCISCO
EXAMINER. A native Californian, she is
a graduate of UCLA, and has a three-
year-old son, Sam.

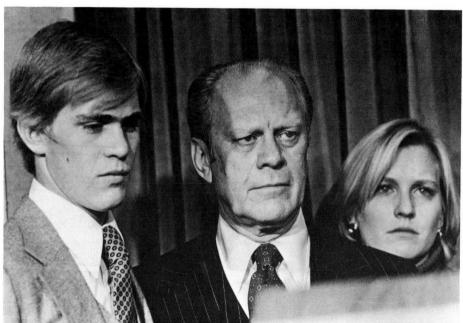

First Prize
"It's All Over"
Teresa A. Zabala, New York Times

Award—Presidential Class

Olympus OM-2 Black Body Camera
85mm f2 lens
Power Winder
Courtesy Olympus/Ponder & Best, Inc.

Second Prize
"Presidential Hangover"
Ronald Bennett, UPI Newspictures

Third Prize
"The First Family"
John Duricka, Associated Press Photos

Presidential

Honorable Mention
"The Titantic"
Susan T. McElhinney, Newsweek

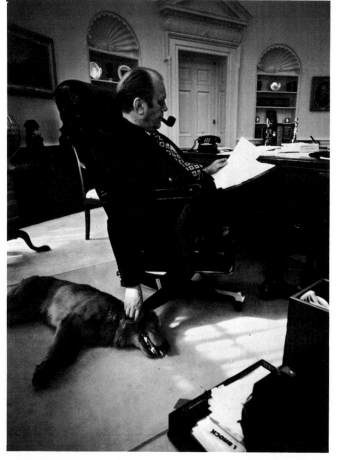

Honorable Mention
"Ford and Liberty"
Bruce Dale, National Geographic

Pictorial Class

Photograph illustrating natural or manmade landscapes.

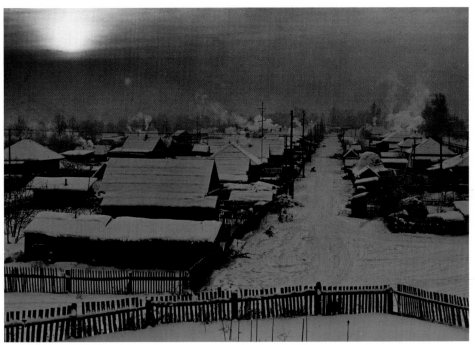

First Prize
"Siberian Village"
Dean Conger, National Geographic

Award—Pictorial

Rollei 35-S Camera with
40mm f2.8 lens
Courtesy Rollei of America, Inc.

45-150mm f3.5 Soligor Zoom Lens with
mount of photographer's choice
Courtesy Interstate Photo Supply

Dean Conger,
NATIONAL GEOGRAPHIC

Dean Congor has been with the *National Geographic* for 18 years, his assignments ranging from tropics to tundra. While in the Altai Region of Southern Siberia, he captured this early morning moment, temperatures ranging around −50°.

Under such extreme conditions cameras must be stuffed beneath parkas to keep the shutters from freezing. Even then, film gets brittle and winding must be done with extreme care. After having been to Siberia off and on for the past four years, one would think Dean had adjusted to the climate. However, he says he's ready for another Caribbean assignment any time. Although this is Dean's first WHNPA First Prize, he has made a number of award-winning photos over his career and was named Newspaper Photographer of the Year by the University of Missouri when with the *Denver Post.*

Pictorial

Pictorial

Honorable Mention
"Winter in the Big Horns"
Emory Kristof, National Geographic

Honorable Mention
"Shorebirds"
Bruce Dale, National Geographic

Picture Story Class

Series of photographs denoting action or continuity in any category.

James Stanfield
NATIONAL GEOGRAPHIC

Jim Stanfield spent from March through November 1975 getting to know the people in this picture story. Carolinas Peyton and his family live on a typical back country Potomac River farm. At 88, he continues to plow his 63 acres with two mules and does blacksmithing for neighbors on rainy days. These photos became part of a special article in the October 1976 NATIONAL GEOGRAPHIC Magazine, "The Nation's River."

Jim has been with the National Geographic since 1967 and previously with BLACK STAR. He was born into a family of newspaper photographers in Milwaukee, and started his career with his hometown paper, the MILWAUKEE JOURNAL.

Award—Picture Story

Minolta Autometer II
Courtesy Minolta Corp.

Nikkormat ELW, Auto Winder, and 50mm f1.4 lens
Courtesy Nippon Kogaku

100-300mm f5 Soligor Lens with mount of photographer's choice
Courtesy Interstate Photo Supply

First Prize
"Rosier Creek Farm-Carolinas Peyton"

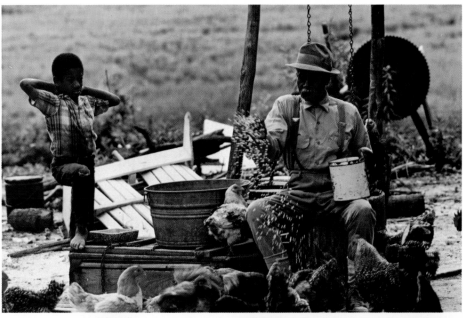

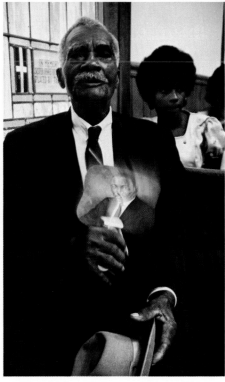

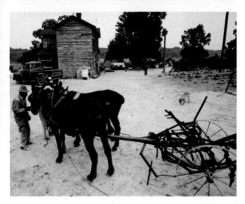

Picture Story

Second Prize
"Melinda's Last Days"
Bernie Boston, Washington Star

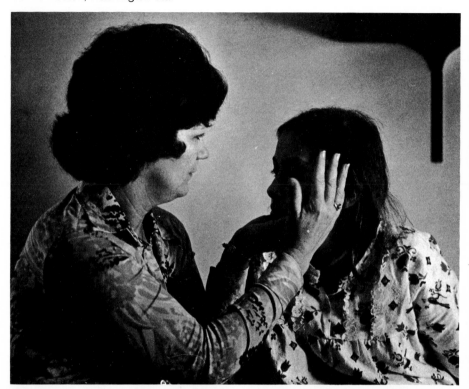

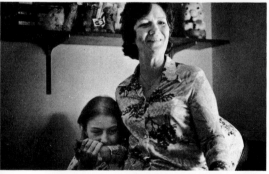

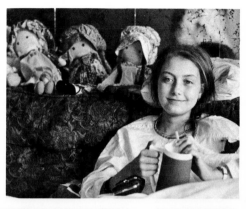

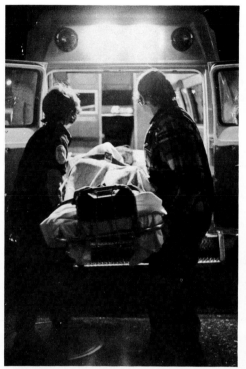

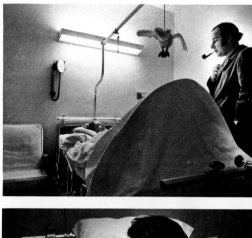

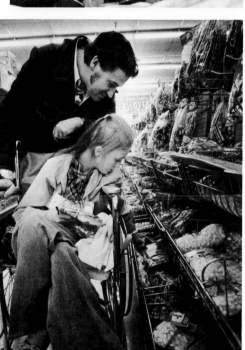

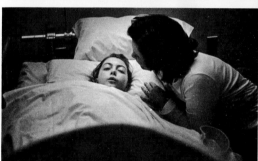

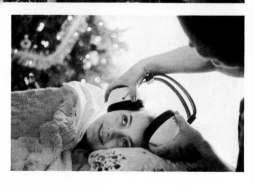

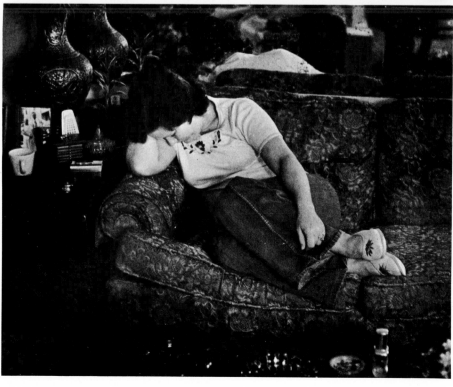

Picture Story

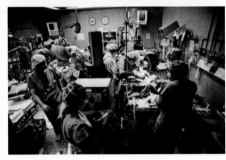

Third Prize
"Shock Trauma Unit"
James Stanfield, National Geographic

Honorable Mention
"Slippery Climb for Annapolis Plebes"
Margaret Thomas, Washington Post

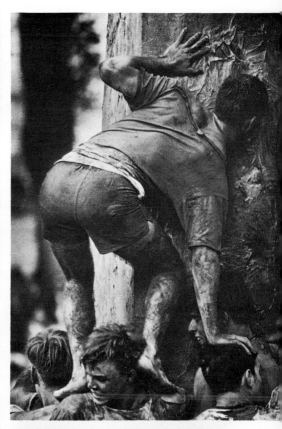

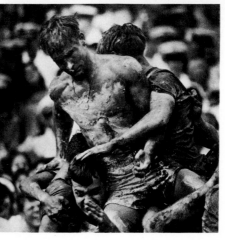

Picture Story

Honorable Mention
"Kansas City Command Post"
Dirck Halstead, Time Magazine

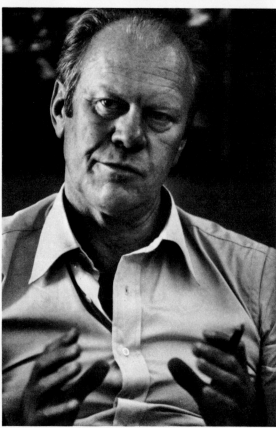

Personalities Class

Character studies or portraits.

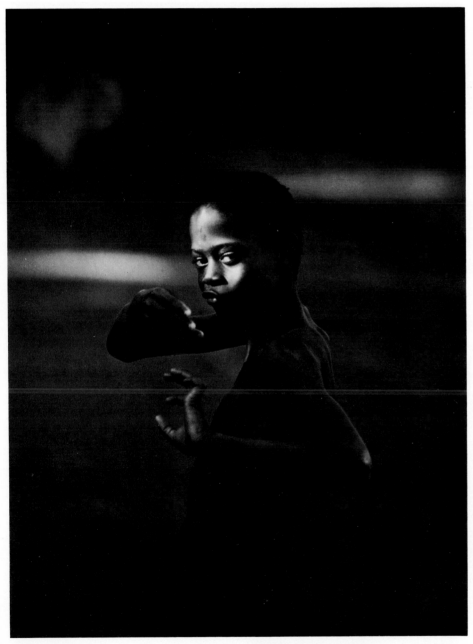

First Prize
"Street Jive"
Emory Kristof, National Geographic

Emery Kristof,
NATIONAL GEOGRAPHIC

Emery Kristof has been with the National Geographic Magazine since graduating from the University of Maryland in 1964, with a B.S. in Journalism. His NATIONAL GEOGRAPHIC assignments over these past 13 years have taken him to every corner of the world, and brought him prizes from the National Press Photographers Association and the WHNPA in previous years.

In late summer 1975, Emery was on assignment in the South Bronx for a story on land use in the United States for the special July Bicentennial issue of the GEOGRAPHIC. It was a hot August, and there had been a number of fires in the area. Kristof was riding with the Fire Chief looking at buildings which had been burned, and the people who inhabited the neighborhoods. The young man in this picture was among several who were fascinated both with the camera and photographer.

Award—Personalities

Ektagraphic Slide Projector
Courtesy Eastman Kodak

Vivitar Model 283 Electronic Flash Kit
Vivitar 70-210mm f3.5 Series I Lens with mount of photographer's choice
Courtesy Ponder & Best, Inc.

Personalities

Second Prize
"He's Retired"
Harvey Georges, Associated Press Photos

Third Prize
"Washington Hustle"
Frank Johnston, Washington Post

Personalities

Honorable Mention
"Hunter"
George Mobley, National Geographic

Honorable Mention
"The Nouveau Riche"
James Sugar, National Geographic

News Class

Photograph of an event, scheduled or unscheduled, which cannot be recreated.

Dirck Halstead
TIME MAGAZINE

The ground was still shaking when Dirck Halstead arrived in Guatemala at 4 PM February 4, 1976. The outside world had known about the monumental quake for only eight hours. Within another 30 hours he was back in New York to meet his Thursday evening deadline, with 10 rolls of black and white film and another eight rolls of color slides to give TIME Magazine exclusive coverage of the biggest natural disaster of the year.

Dirck's photography career has been filled with deadlines, crises, and catastrophes, whether with TIME since 1972, or previously with UPI from 1956. In 1965, Dirck set up the UPI photo bureau in Saigon and doubled as bureau manager and combat photographer for two years. In 1972, he joined the TIME staff. His 1975 photos of the final weeks of American involvement in Vietnam won him the coveted Robert Capa gold medal and the American Newspaper Guild's Headliner Award.

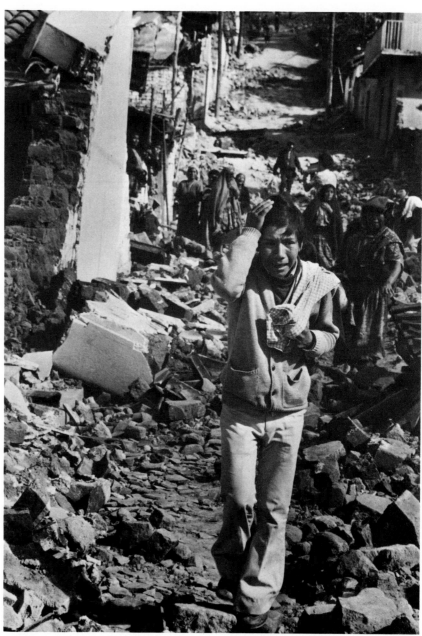

First Prize
"The Survivor"
Dirck Halstead, Time Magazine

Award—News

Canon AE-1 Camera
50mm f1.8 lens
Power Winder and Electronic Flash
Courtesy Canon, U.S.A., Inc.

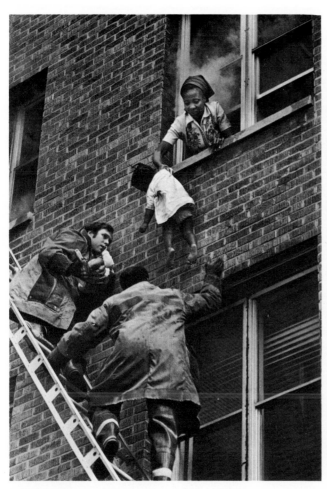

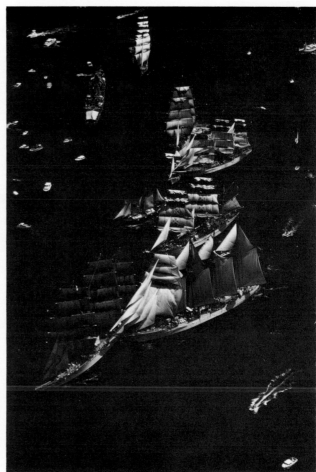

Second Prize
"Rescue"
James Parcell, Washington Post

Third Prize
"Traffic Jam on High Seas"
Gilbert Grosvenor, National Geographic

News

Honorable Mention
"Brother Billy"
Peter M. Bregg, Associated Press Photos

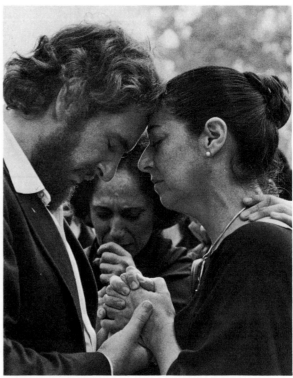

Honorable Mention
"Death of a Diplomat"
Timothy A. Murphy, UPI Newspictures

Feature Class

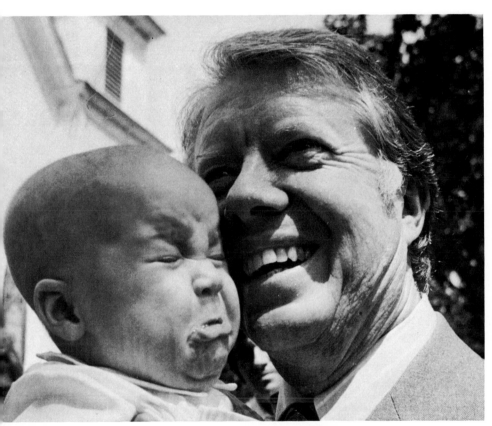

Peter Bregg,
ASSOCIATED PRESS

The Plains Baptist Church was a popular tourist spot in the summer of 1976. While on assignment there for the Associated Press, Peter Bregg made several classic "crying baby" shots when parents posed their children with the campaigning Jimmy Carter.

In this case the parents had come from a nearby Georgia town that Sunday morning and while family snapped away with their Instamatics, Peter caught this shot which impressed this year's judges. Peter has been wtih AP in Washington for the past year, having come from a three-year assignment with the AP Bureau in Boston. Prior to that the Canadian-born Peter was with the Canadian Press Wire Service in Ottawa where he began as a copy boy in 1967. He has received many awards for his photography, including NPPA Regional Photographer of the Year for Region I in 1975, the National Newspaper Award in 1969 and a second place from the World Press in The Hague last year.

First Prize
"Strangers"
Peter Bregg, Associated Press Photos

Award—Feature

Leica R-3 Camera with
35mm f2.8 lens
Courtesy E. Leitz, Inc.
Rockleigh, N.J.

85-205mm f3.8 Soligor lens with mount of photographer's choice
Courtesy Interstate Photo Supply

Feature

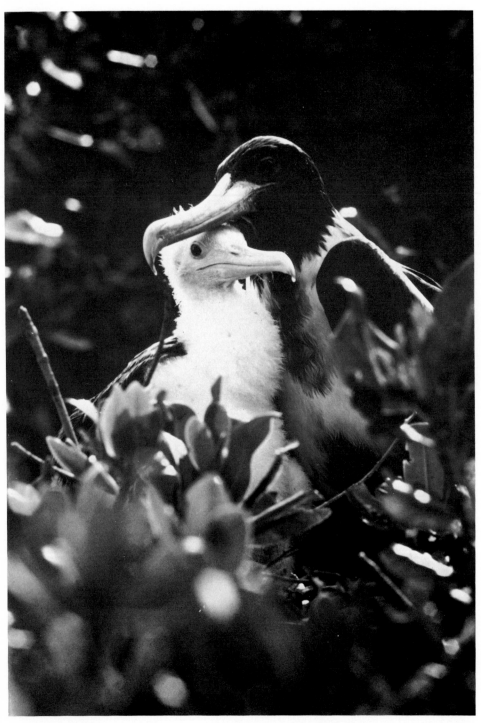

Second Prize
"Frigates—First Nesting in US"
Bianca Lavies, National Geographic

Feature

Sports
Class

Photograph taken of any sporting event.

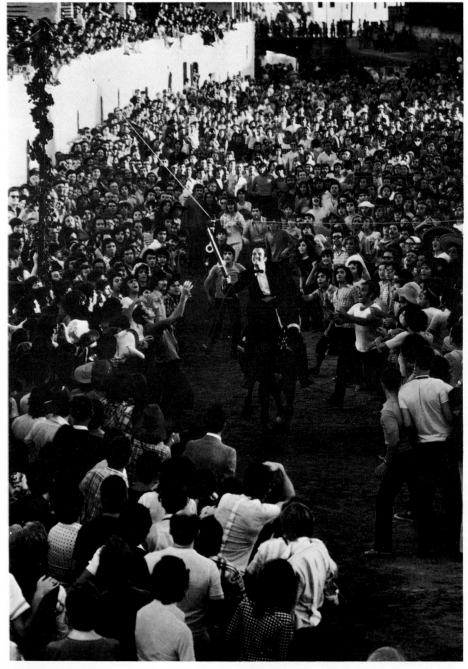

James A. Sugar
NATIONAL GEOGRAPHIC Staff

On Menorca, one of the Balearic Islands of the Eastern coast of Spain not far from Barcellona, festivals are taken quite seriously. In early Spring 1975 Jim Sugar happened to have camera in hand during a particularly exciting festival, but couldn't get the right angle on the scene. After some maneuvering, he was able to work his way into the coveted VIP box, reserved for local dignitaries, to get the height needed for this special shot of the jouster.

Jim was one of the youngest photographers ever to join the National Geographic staff when he arrived in 1967 as an intern. During these 10 years he has won national and international awards for his photos and travelled extensively in Western Europe as well as the United States on special assignments.

Award—Sports

Nikon Photomic F-2 Camera
with 50mm f1.4 lens
Courtesy Nippon Kogaku

First Prize
"The Jouster"
James Sugar, National Geographic

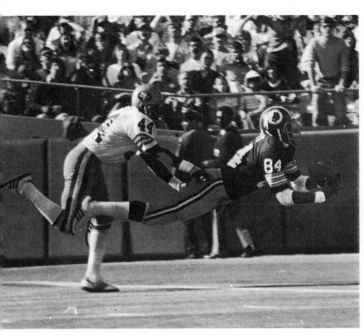

Second Prize
"Flying Catch"
Randolph Routt, Washington Star

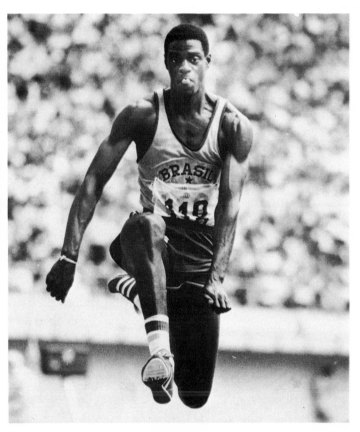

Third Prize
"Tongue Triple Jump"
Ronald Bennett, UPI Newspictures

Sports

Honorable Mention
"Bad Weather Knockdown"
Bob Grieser, Washington Star

Honorable Mention
"Ex Champion"
James Stanfield, National Geographic

A Look At The White House News Photographers Annual Photo Exhibit

JERALD C. MADDOX,
Curator of Photography
The LIBRARY OF CONGRESS

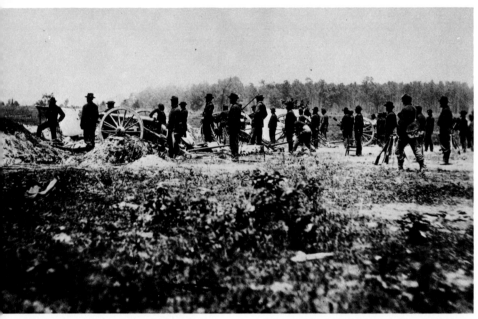

Matthew Brady with Captain James H. Cooper's battery. First Pennsylvania Light Artillery before Petersburg, June 21, 1864.

"The Brady photograph will show us a static scene, the objects and people lined up and arranged, unmoving."

The White House News Photographers Association extends its thanks to the Library of Congress for once again providing space for our annual photo exhibit.

You are cordially invited to view the exhibit at the Library of Congress from April 30th to July 17th.

In accepting the invitation to write about the WHNPA exhibition, I thought it would be a relatively easy task. I have seen every exhibition since I have lived in Washington, which is over 10 years now, and feel quite familiar with this annual show and the images that comprise it. As I began to work my way into the subject, however, I began to realize that this would be more difficult and complex than I had thought.

To begin with, consider the basic element of this exhibition and my primary subject, the photographs made and shown every year by the members of the White House News Photographers Association. The implication is that these images are all more or less of a kind—that they are all news photographs. It is obvious that many of them are, but just as many are not. To get around this, we might consider describing them as examples of photo-journalism, which is a broader concept than "news" photograph, but even with this description there is something left over. The only common factor I am sure of is that the photographs were all made by members of the same organization.

There is, however, still enough overall consistency to allow some general observations. Originally, and still to a large extent, the emphasis has been on the "news" photograph, especially if we are content to define that as a picture which is primarily intended for publication in a newspaper or magazine recording current events. One might also include the use in film and television, but these do not basically change the content of the material which goes into this exhibition. Over the years there is a sameness to these images, picture after picture of the smiling, hand waving, hand shaking politicians who are so much the center of this city, plus assorted supporting players and other incidents. There have been some changes over the years, but they tend to be more matters of technology and technique, such as the increased use of color, and a greater emphasis on the candid, unposed scene.

This apparent similarity can make it difficult to approach these pictures, but there are differences between them, and if these are subtle, then perhaps they are are all the more significant for that. These images can and do function in many different ways, on varying levels of meaning, according to subjective, personal reactions, but it is the aspects they have in common which are most important. There is, for example, the photographic tradition out of which these images come. It is almost as old as the medium itself, with origins in Roger Fenton's photographs of the Crimean War. It was more firmly established and expanded in this country during the War Between the States, and by the beginning of the 20th century was functioning as a primary force in our culture.

The tradition of news photography appears to have undergone great changes over the years, and one has only to compare a view taken by one of Brady's men with the latest image from Northern Ireland or Lebanon to understand this. The Brady photograph will show us a static scene, the objects and people lined up and arranged, unmoving. The focus will be sharp, and there will be a full range of tonalities gradated from dark to light. A contemporary war photograph will seem haphazard by contrast, the figures will be caught in

"A contemporary war photograph will seem haphazard by contrast, the figures will be caught in action, unpassed, and perhaps even a little blurred."

"We should be aware of the effort and experience which was required to get the images . . . some might think that it is largely a matter of luck . . . but it seems some people have more luck than others."

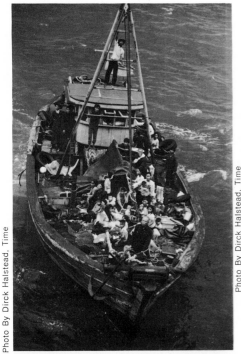

Photo By Dirck Halstead, Time

Photo By Dirck Halstead, Time

Photo By Dirck Halstead, Time

Photo By Linda Wheeler, The Washington Post

action, unposed, and perhaps even a little blurred. The tonalities will tend to be more contrasty, with fewer gradations. The differences which seem so striking are perhaps as much a reflection of changes in technology as anything else. There remains a common, unifying element in all of these images, and it is from this that their significance and meaning comes.

Underlying all of these images is the idea and the impulse towards communication. The overwhelming majority of these pictures is concerned with presenting and conveying facts, visual

records of particular events, individuals, and places. The primary motivation is found in the material, tangibly comprehensible object or event, taken, recorded and presented—sometimes as a thing in itself, sometimes as part of a larger idea. This factual element is the important thing, not the medium or style in which it is presented. The information may be complex and require verbalization for complete understanding, or it may be presented entirely in visual terms. It seems to be at its best when it is like good prose, clearly and simply stated.

This exhibition is always one of the most popular shows held in the Library, and while it might be assumed that this would be obvious because the material is so familiar and accessible to so many people, there is probably more to it than that. Consider that while we may see strange and exotic things recorded in these pictures, these tend to be the exception. What is more important are the commonplaces of our shared existence: the personality, the dramatic accident, the weekend game, cute kids, the inconsistencies of weather—these events and happenings which we have all experienced directly or indirectly. They are brought together and seem to look

alike in these photographs, but perhaps this gives a sense of continuity and consistency, and this should be emphasized. It may be that as we see these pictures, we draw from them a sense of the common life found here in presences and events already known. Familiar faces and events which we have seen before and will see again, providing in their familiarity and continuity a sense of security. These photographs function something like a family album, but on a larger scale. These pictures are a part of our lives. In them, people and events are are made common for us all, and when we see them it is possible they tell us who we are and where we have been. They become part of our history, they humanize the famous, and open the world to us.

It is also possible to consider these photographs in terms of their craftsmanship and technique, but here again when looked at over the years, they seem very much alike. Perhaps there is a certain amount of monotony in their techniques, but much of this derives from the fact that the situation under which the pictures are found are similar. We should be aware of the effort and experience which was required to get the images: this is most dramatic and obvious in the case of the battlefield photographer, but these

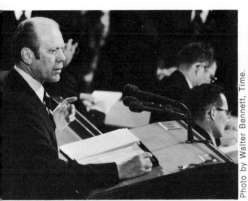

Photo by Walter Bennett, Time.

Photo by Walter Bennett, Time.

Photo by Walter Bennett, Time.

"There is a conditioned awareness of eye and mind that finds the instant which is significant and meaningful . . . It is not simply a question of photographic technology or camera technique, but more the state of being able to recognize and respond to the movement of objects and people within a dynamic environment."

qualities are important in all of the work shown. Some might think that it is largely a matter of luck—of being in the right place at the right time—but as one becomes familiar with these shows over the years, it seems that some people have more luck than others. There is something to this business of being a news photographer which should be described and appreciated. There is a conditioned awareness of eye and mind that finds the instant which is significant and meaningful. It is not simply a question of photographic technology or camera technique, but more the state of being able to recognize and respond to the movement of objects and people within a dynamic environment. It is a skill which cannot always be taught, but apparently can be learned—although to a large degree it may also be a gift which must be there in the first place before it can be developed.

One might talk of art at this point, but I hesitate to use that word because it brings in an element which can confuse our appreciation of these photographs. These days the art of photography is a very fashionable thing, and the current emphasis on photography as art does

bear upon this exhibition. The problems derive from the definitions of art and how they are applied to photography. For many of the people who see these pictures, they are art to the extent that they are two dimensional images which can hang on a wall and serve a decorative or communicative function. For many people, this is all that is required to make art, and it undoubtedly contributes to the satisfaction they derive from these images. The point that should be made is that art is not so much a thing or a medium as it is an attitude. It is a question of conception and manipulation, presentation and reception. To assume that just because we see a well made print taken from a properly composed and processed negative that we are dealing with art is a deception, since much of what makes a photograph an art object has to do with the intent of the photographer when he makes the picture, and not with his technical photographic skills. In many of the pictures in this exhibition, the intentions of the photographer when making the picture had very little to do with art—at least if we define it in terms of what we see on the walls of many galleries today. But if these pictures are not art in those terms, they are not any less a form of significant expression. It should always be emphasized that the expressive potentialities of photography are much greater than its use as a medium for aesthetic expression. While the pictures in this exhibition may be art for some, they serve a more important function in bringing us a wider and deeper under-standing of the world that we experience every day. If there is something here that is art or functions like art, that is well and good, but I tend to think of it as a bonus we can appreciate and enjoy—and not the primary motivation for making or appreciating these photographs. The basic significance of this exhibition and these pictures is not found in their art. The medium is not the message, but the larger view the medium conveys, and the message is ourselves, all humanity and the world we inhabit.

A Special Look At Some News Events

ART BUCHWALD

Art Buchwald
Syndicated Columnist

Billy: "The First Ah'm Going To Do If He Gets In The White House Is Steal Me A New Chair."

Photo by Dirck Halstead. Time Magazine.

"I Knew I Shouldn't Have Bought These From A Yemen Optomatrist."

Photo by Frank Cancellare. UPI Newspictures

*"I Thought They Were Going To
Make Me The Head of The CIA."*

*"Susan, You Come Out Of There
Immediately!"*

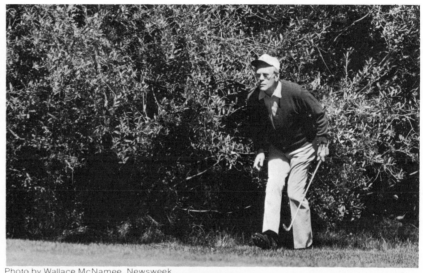

*"Tell The Milkman I Don't Need Any
Today."*

*"When You're Away From Your Loved Ones,
Why Not Call Them Long Distance?"*

Another Look
At Op Sail '76
By Nelson Rockefeller

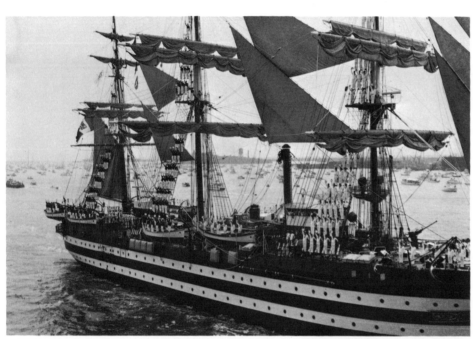

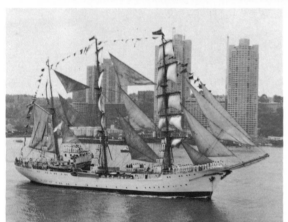

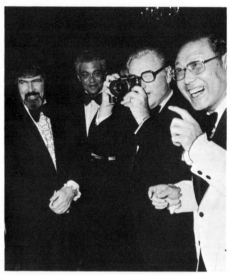

The day of Operation Sail was one of the greatest days for America in my experience, for it dramatized a heritage that we are uniquely fortunate to have—a heritage of reaching out to the world in peaceful commerce that has done so much to make America great.

Operation Sail was a thrilling spectacle and, of course, gave me a great opportunity to indulge in my hobby, photography—(obviously I am no competitive threat to the members of the White House News Photographers Association). But, the greatest significance of Operation Sail and the whole Bicentennial celebration, is its challenge to us for the future.

Left to right - WHNPA members Chick Harrity, AP, and Bernie Boston, Washington Star, with former vice President and eternal photo buff Nelson Rockefeller (holding 1976 Grand Prize, the Olympus OM-2) and Shigeo Kitamura, President Olympus Optical Company, Ltd.

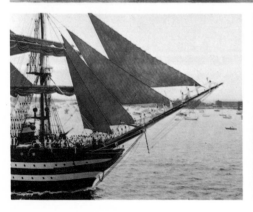

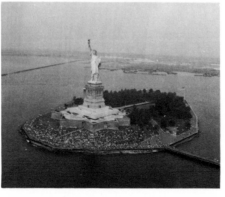

A Look Through The Lens Of Senator Barry Goldwater

Havaisui Indians from northern Arizona, by Barry Goldwater

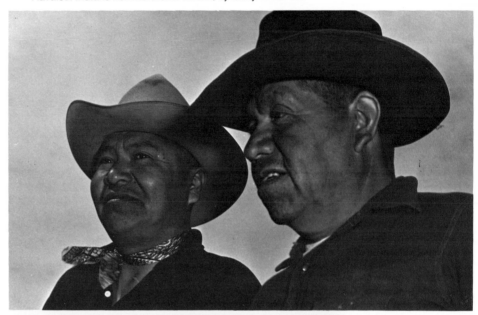

My interest in photography was generated about forty-five years ago by the obvious need for pictorial coverage of Arizona to supplement my rather large library on the same subject. I started with an old Graflex and still have it. Once in a while I use it, but today I use the Rolleiflex for black and white and the Nikkon for color.

It has been one of the most rewarding, prolonged experiences of my life because now I can look on a pictorial library of over 10,000 black and white negatives, I don't know how many thousands of feet of movie film, and probably eight to ten thousand color transparencies of my state and, I might add, other places around the world.

Five books of my photographs hav been published, and I believe I am the oldest contributor to ARIZONA HIGHWAYS MAGAZINE which is one of the best photographic magazines in the country. Naturally with this background, I have had a constant interest in the work of the Press Photographers and I have nothing but admiration for the skill and quality they have exhibited. In my humble opinion, far too little recognition is given these people who make the news understandable and interesting, and I congratulate them for having the Annual Awards Book.

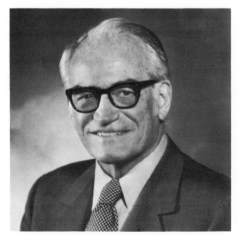

Senator Barry Goldwater, R. Arizona

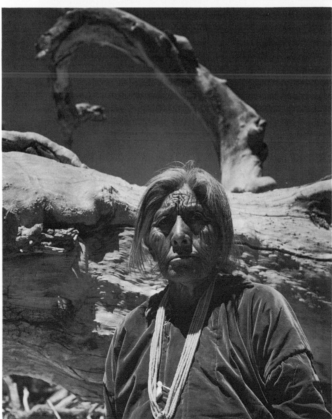

Navajo Indian from northeast Arizona, by Barry Goldwater

True Confessions Of A Photo Contest Mastermind

Or: How To Treat The Deadline Blues

LINDA WHEELER,
The WASHINGTON POST

It's six a.m. The phone is ringing. It must be the office calling. Maybe there has been a bombing, or a fire, or an assassination. I get the phone on the second ring.

"Hello." (somewhat breathlessly).

"Hello. Is this Linda Wheeler? The contest chairman?"

"Yes." (heart sinking . . . clearly not the office calling).

"Well, I'm a member of W.H.N.P.A. and I want to ask you something about the rules. It says here that for a picture to be eligible for the contest, it has to have been made or initially published in 1976. Is that right?"

"Yes." (eyeing the bed and wondering how long it would take to get back to sleep).

"Well . . . I have these marvelous pictures which I made and published in 1975. And I didn't have time to enter them in last years contest. So, may I enter them in this years contest?"

"No. The rules are clear on that point." (now seated on the floor).

"Yes, but you don't understand. They are very good pictures. They may win."

"Yes, well. What can I say? We'd all like to enter favorites from other years. I'm sorry but they are not eligible." (now leaning back against the wall watching the sun strike the row houses across the street).

"Well . . . could you make an exception?"

"No, I'm afraid not."

"Well . . . did I wake you up?"

That call marked the opening of contest season. This is my second year as contest chairperson, and I should have been expecting such calls. That one came in early—about a month before the contest was judged on January 29. The best ones usually come in during the last two days. The call that came to my office is what I call the annual "deadline blues" call.

"Linda, I want to talk to you about this deadline. Why is it so early?"

"Well, you know each year we set the deadline by the time needed to get our material to the printers for the Awards Book, and to recuperate before hanging the show at the Library of Congress."

"Well, Linda, I can't get my pictures there in time. You know you may not have anybody entering *your* contest. Some of us are hard working photographers . . ."

When the contest becomes *my* contest, then I know we are down to the diehards.

And then there is the night the contest closes. The Press Photographers Gallery in the Dirksen Building is full of photographers laying out picture boards, mounting prints, and sticking stickers to the back of each entry. Everything seems to be going very well. The early morning caller shows up with a huge stack of carefully done entries. He eyes me and says, "Don't worry. These are all from 1976 . . ." Then the "deadline-blues" photographer shows up with time to spare. He looks relaxed and whistles softly as he arranges his entries in a neat

stack. Nothing more is said about the early deadline.

It is one-half hour till closing time. The phone rings and a man shouts, "Don't close. I'm coming. From the airport." And he hangs up.

At exactly one minute to the hour, the sound of heavy boots and panting breath can be heard in the hallway. The door bursts open and a very over-burdened messenger staggers into the room and flops a heavy bundle of prints on the desk. "Made it," he says. "All the way from Dulles in 28 minutes."

The clock strikes nine. The contest is closed. In less than 48 hours the contest will have been judged.

The phone rings. It is early Monday morning. I do my leaping act and catch it on the third ring.

"Hello, Linda? Listen I want to talk to you about that judging . . ."

Newsfilm Judges Deliberate entries—February 12, 1977—left to right—BOB BRADDON (NPPA Cameraman of the Year 1976) KPRC-TV Houston, Texas, ED HOOKS Cameraman WBZ-TV Boston, Mass., DON VERPLOEG Manager of Motion Picture Services Eastman Kodak

Linda Wheeler, WASHINGTON POST, Chairperson, 1976 Contest Committee

Reflections on the "Exactly Repeatable" Visual Statement

David Haberstich, Curator of Photographs
NATIONAL MUSEUM of
HISTORY and TECHNOLOGY
SMITHSONIAN INSTITUTION

In 1953 William M. Ivins, Jr. wrote that ". . . the various ways of making prints (including photography) are the only methods by which exactly repeatable pictorial statements can be made about anything." He asserted that the invention of the exactly repeatable pictorial statement is fundamental to our civilization.[1]

Ever since its introduction in 1839, the photograph has been justly praised for its power to record with optical clarity and veracity all the minutiae before the lens. The manifest destiny of a process capable of such power seemed to many to be the mass production and dissemination of images in a manner analogous to the mass communication of the written word. Yet within the mainstream of photography there have been notable exceptions to this rule: processes such as the daguerreotype, ambrotype, and tintype, which were dominant forms during various periods, produced images which in fact were not easily "exactly repeatable" — each image was unique, repeatable only in inferior second generation copies. William Henry Fox Talbot's invention of a negative-to-positive photographic system, which is fundamental to much — but by no means all — of contemporary photography, was introduced in the same year as the daguerreotype, yet the latter was the predominant form of photography in the United States for years and Talbot's American agents failed to sell a single license for the rights to use the negative-to-positive calotype process.

The calotype was used to a greater extent in Europe than in the United States. The possibility of exploiting the potential of photographs for mass communication was realized by Louis Désire Blanquart-Evrard at his photographic printing establishment, the Imprimerie Photographique, at Lille, France, in the 1850's. There, efficiency, ingenuity, and mass production techniques were combined with a special printing paper of comparatively high sensitivity, enabling the firm to produce thousands of photographic prints per day to illustrate portfolios and books

A fragment of daguerreotype of **Louis Jacques Mande Daguerre,** inventor of the daguerreotype process, taken in 1848 at Bry-sur-Marne, France, by Charles R. Meade. From the History of Photography Collection, Smithsonian Institution.

documenting exotic places, works of art, and other subjects — communicating visual information to as wide an audience as possible. In the United States, by contrast, the desirability of such mass communication was not felt immediately; instead, Americans were entranced by the very uniqueness of each jewel-like daguerreotype. Lacking the strong European tradition of professionally painted portrait miniatures, Americans flocked to have their daguerreotypes made for intimate, personal, and family keepsakes. Later, less elegant, less expensive forms such as the ambrotype and tintype superseded the daguerreotype but perpetuated this tradition of unique, non-repeatable images. Variations of the tintype method were practiced well into the twentieth century.

The tradition of unique photographs survives to the present day in Polaroid prints and in reversal-processed color transparencies in which the original negative image is obliterated and transformed into a positve, unique image in a way nearly analogous to destroying the printmaking capability of a collodion negative by backing it with a dark substance and effectively reversing it into a unique positive. However, unlike unique prints, color slides are often intended for a wider audience via screen projection. Unlimited numbers of color prints can be made from transparencies and Polaroid prints can be copied, of course. Advanced technology makes this practice easier and more satisfactory in terms of quality than the cumbersome production of daguerreotype copies had been.

Photomechanical reproduction extended the potential for the exactly repeatable photographic image. High-speed presses can produce millions of identical images in the same time that Blanquart-Evrard made mere thousands. Yet these are two different technologies, and the photomechanical print is seldom a precise reproduction of a photograph. Most photomechanical prints are second generation images which cannot convey all the subtleties and nuances — they cannot communicate all the information — contained in the originals.

Photojournalism presumably attained its heyday or classic period with magazines such as *Life* and *Look,* and with their demise a change in the use of photographs has occurred. The change is attributable in large measure to television documentation. While there will not cease to be a need for still photographic communication in the form of newspaper, magazine, and book reproductions, its usage in the journalistic sense has declined noticeably, and photojournalists do not have the same situation with regard to magazine outlets as in the past. The immediacy, added realism, and information provided by the television documentary sequence have made the still picture "story" appear somewhat dated. At the same time, greater visual sophistication has rendered

Note
1. William M. Ivins, Jr. *Prints and Visual Communication.* Cambridge: Harvard University Press, 1953, pp. 1-2

"Ever since its introduction in 1839, the photograph has been justly praised for its power to record with optical clarity and veracity all the minutiae before the lens."

"Photomechanical reproduction extended the potential for the exactly repeatable photographic image."

still photography suspect. A generation ago, the McCarthy hearings demonstrated that the still photograph was not quite the automatic reliable witness that it had been presumed to be. Photographs can be altered, faked, and abstracted out of context, and it is symptomatic of this sophisticated distrust that photographs no longer are offered as unquestioned evidence in the courtroom. Aside from deliberate trickery, there is the growing awareness that any still photograph is an abstraction from reality out of context, and this fragmentation out of the total space-time continuum must always be borne in mind. In other words, still photographs can be ambiguous. Yet this ambiguity can be their strength. There will always be a need for effective still photographs, including photojournalistic material, even in the face of television because a good single photograph can be more memorable, more poignant, more quintessential than the flow of imagery in a film or videotape. While the search for essences in still photographs may become more critical, sophisticated, and ultimately subjective, the quest will indeed continue.

The problem is that photography is capable of being a precise scientific, objective tool under strict laboratory conditions, but it is not necessarily automatically objective in human hands and under human conditions beyond the scope of clinical rigidity. This need not be surprising or distressing, but it must be recognized. Many photographers are beginning to utilize the ambiguity of photography, free of rigid scientific controls, in order to communicate their own feelings and subjectivity in a fascinating, creative manner based upon that tension between reality and artifice, truth and fiction, which photography can suggest. There is, therefore, a growing tendency for photographers to personalize their work, whether their orientation is as artists, photojournalists, or whatever label they prefer. Mass communication in the form of magazine and newspaper reproduction is asssuming less significance, even for photojournalists, many of whom, like Charles Harbutt and Burk Uzzle, are producing books of their work intended for markets far smaller than the enormous circulation of *Life* or *Look*. In these books and in the growing interest in portfolios of all types of original photographic prints, the emphasis is on quality rather than mass communication. The greater awareness of photographs as works of art has aided this tendency to minimize the significance of that property of

photography and photomechanical reproduction for the proliferation of unlimited quantities of "exactly repeatable" pictorial statements. The tendency toward limiting copies of photographs is becoming strong, and many artist-photographers prefer to return to the notion of the unique, unrepeatable photograph.

Clearly, the position of still photojournalism as a medium of mass communication is being re-evaluated, and what will emerge perhaps cannot be accurately predicted now. It is possible that we are experiencing only a swing of the pendulum between the poles of photographic tradition, and the picture magazines and other mass markets for still photographic reproduction may again emerge triumphant. Unquestionably, photojournalism is a vital and firmly established tradition in the history of photography and communication, but the outlets for photojournalists' work continue to be in a state of flux.

A fragment of daguerreotype of **Horseshoe Falls, Niagara Falls, ca. 1850,** attributed to Platt D. Babbitt. From the History of Photography Collection, Smithsonian Institution.

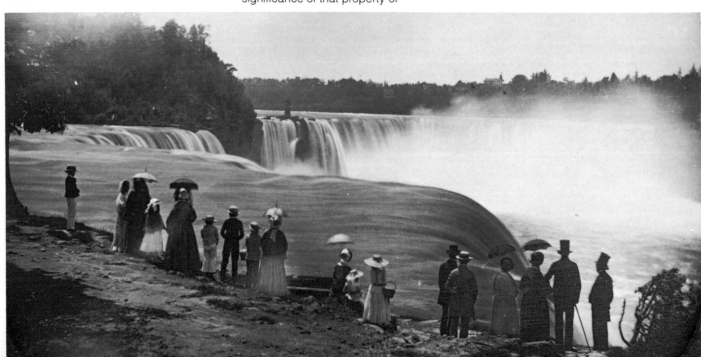

The Constant Photographer By Howard H. Baker, Jr.

I'm an addicted photographer, a devoted consumer of photography, and I love pictures. I like all pictures . . . bad ones, good ones, mediocre ones. I think they are all nice, thin, appetizing slices of life and I enjoy them.

I have been carrying a camera most of my life—since I was 12 years old, in fact. I carried the Kodak Bantam Special and Ektra, have used Leicas and Hasselblads, Crown Graphics, Speed Graphics and View Cameras, loving them all for one feature or the other. I've been tempted from time to time to go into camera collecting but that's really not for me. I remember fondly all my episodes with different cameras and I sometimes regret the financial loss after having sold them before their time, but that's not my main hobby.

My real hobby is color photography and I keep an extensive negative file. My file dates back to 1937 and is self-maintained. Because of the short life of color negatives, I put them in aluminized paper envelopes from Kodak, heat seal them and file them away systematically in my freezer at home. I find after years of experience that it's not only the safest way, but it's the only way to handle them if you expect them to last a long time.

Cameras have been with me through high school and college, World War II, and political campaigns. Looking at my negative file, it's truly a remarkable nostalgia trip but also an extraordinary way to write a diary. Today, if somebody wants to know what I'll do when I leave the Senate, I'll tell them, 'I may have no money, or no reputation, but I'm going to have alot of good pictures!'

I keep my negatives filed by year. The file folders start out with the year and the number roll of film, such as 1937-1. Last year, for instance, I got up to 1976-250 or so. For a man who only has occasional opportunities to work on photography, that's a lot. Each roll is contacted and the sheets placed in loose leaf folders with negatives in file folders. The reason for that is I can get the proof sheet out to look at and don't have to go through the deep freeze to find them.

I now shoot mostly with Kodacolor II negative print film, occasionally using the faster Vericolor (ASA 100). I am totally convinced that ultimate color prints come from color negatives and paper prints rather than direct reversal printing from slides or even from separations and dye transfer processes. I really think the warmth and open shadows of color negatives are superior. The sharpness is being improved as time goes by. I think the logic of the negative-positive system is so overwhelming that someday it will be the dominant medium. I started printing color work in my teens, back in the days when dye transfer printing was called "wash off relief." That got its name from using hot water to wash the unexposed gelatin off from the matrix. After that, the process name changed to dye transfer.

Not only do I appreciate photography as an insider, I also feel that I am a fair observer of the world of photo-journalism. I'm probably the only person you know who glances first at the front page pictures and then at the credit lines beneath them. I think the Washington photo press corps is by far one of the best in the world. They manage to bring originality and life and vitality to scenes that are bound to be stereotyped to them. They avoid, to a remarkable degree, the gimmickry that characterizes most stereotyped photographs. They're really very good. I'd like to see more Pulitzers awarded to photographers.

I have had a few occasions when my camera hasn't been a welcome part of a meeting. I have never physically had my camera taken away from me but often the glances have been unmistakable. However, the opposite has also happened. I was talking with George Meany one day in this office about a serious matter and he was biting the stub of his cigar. I was mesmerized by it and finally I couldn't resist the temptation and asked if I could take his picture. Not only was he not offended, he was delighted and lit the stub of the cigar a few more times for me.

I have had other nostalgic times in Washington, such as Inauguration Day, 1977. After the Inauguration, John Rhodes and I escorted President Ford to the West Lawn of the White House where

Howard Baker, the constant photographer, with his ever-ready Leica which he carries in his brief case and keeps in his desk in the Capitol.

"I think a century or so from now ... the more remarkable reporters of the day will be the visual ones."

he walked out onto the grassy area and got on the Presidential helicopter for the last time and waved. I stuck that little Leica in the air and got one picture with Rockefeller in the foreground, Betty Ford looking tearful and President Ford waving good-bye.

Because I feel I understand the medium so well, I have become a friend of the photo press corps. I think the Washington photographic press corps has a better feel for the ambience of the Federal City and the federal situation than any other group, either in the writing press or in the visual press, than I have ever seen. And I don't say that to curry favor, although most of them are my friends. I think a century or so from now, assuming that you can find somewhere to save these negatives, the most remarkable reporters of the day will be the visual ones. That's not to diminish the importance of the written word but photography is unique. The expression of the medium and its potential, here in Washington especially, has so much originality, vitality, warmth, and understanding. I don't find that anyplace else in the world.

Local Republican Headquarters in Rogersville, Tennessee, as seen through Baker's lens.

Lucretia Crockett, a descendant of frontier hero Davy Crockett, preserved on file by Baker.

Selections

Presidential
Class

"If the Shoes Fit"
John Duricka
Associated Press

"Mother"
John Duricka
Associated Press

"Pond Draining In Plains"
George Tames
New York Times

"Out Of Exile"
Wally McNamee
Newsweek

Pictorial
Class

"Siberian Village"
Dean Conger
National Geographic

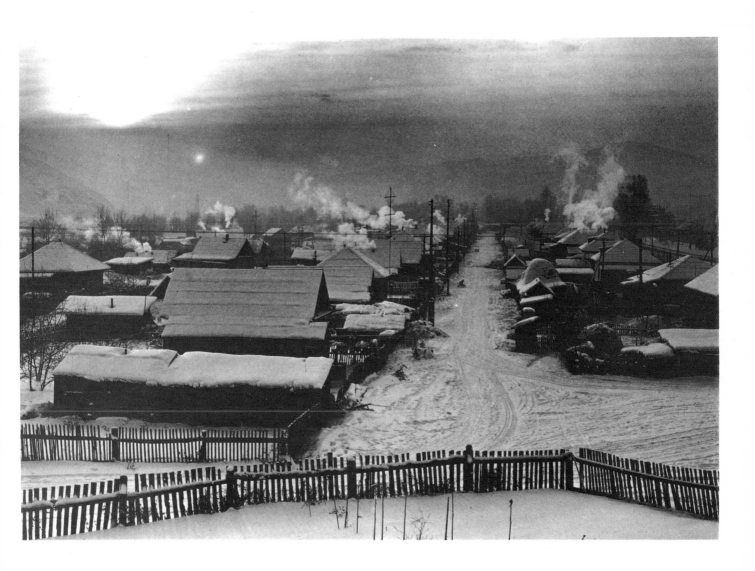

"Morning's Majesty"
James Stanfield
National Geographic

"Gone With The Wind"
Bob Grieser
Washington Star

"Punta Del Diablo"
Bruce Dale
National Geographic

Personalities

"Street Jive"
Emery Kristof
National Geographic

"Sugar Ray Leonard And Son"
Craig Herndon
Washington Post

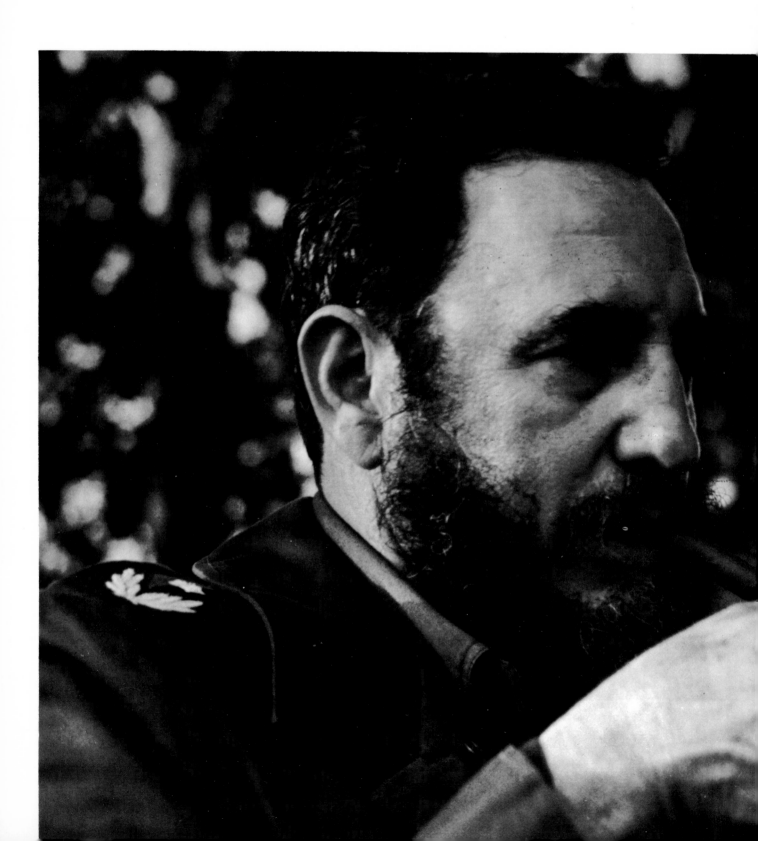

"Fidel Takes A Polaroid"
Fred Ward
Black Star

"Man Of The Sea"
Matthew Lewis
Washington Post

News
Class

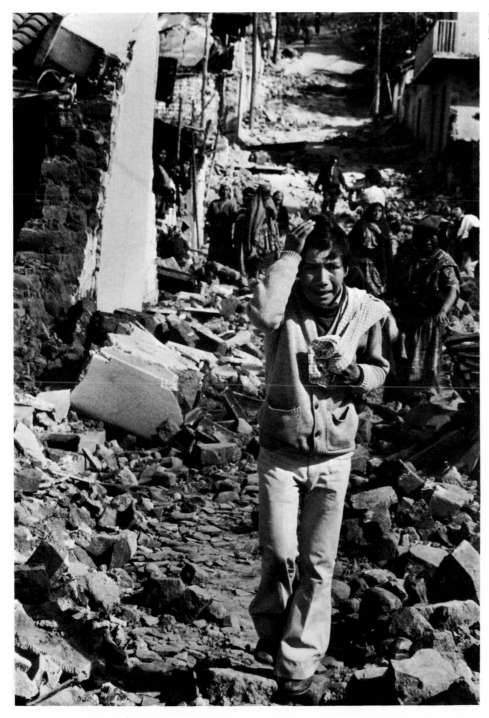

"The Survivor"
Dirck Halstead
Time Magazine

"Guatemala Earthquake"
Dirck Halstead
Time Magazine

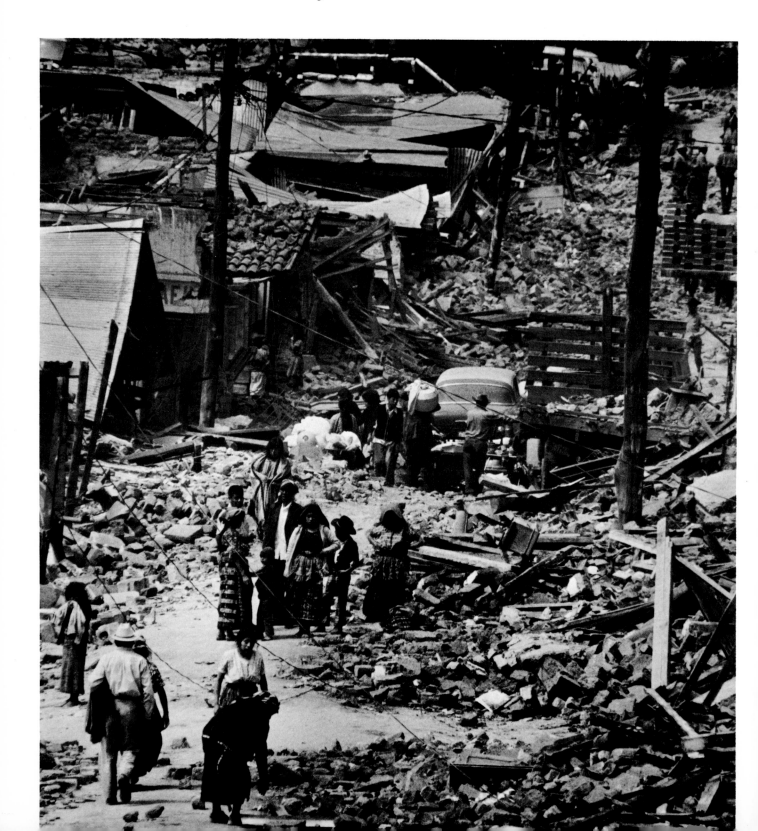

"Earthquake, Guatemala"
W. E. Garrett
National Geographic

"Election Leftover"
Charles Tasnadi
Associated Press

"Metro Rescue"
Joseph Silverman
Washington Star

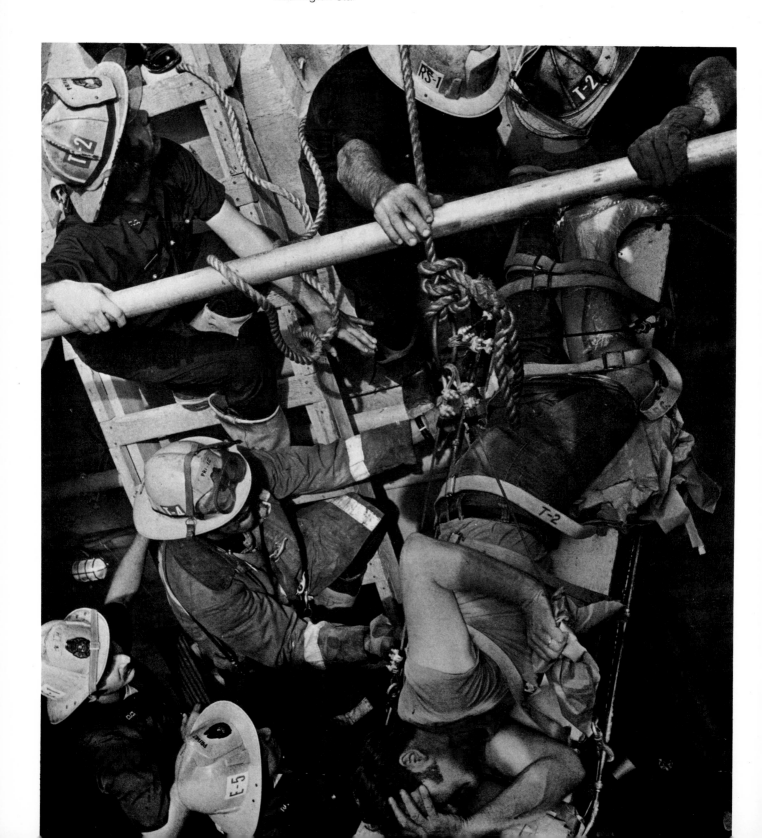

"Their Last Cigarette"
Harry Goodman
Washington Star

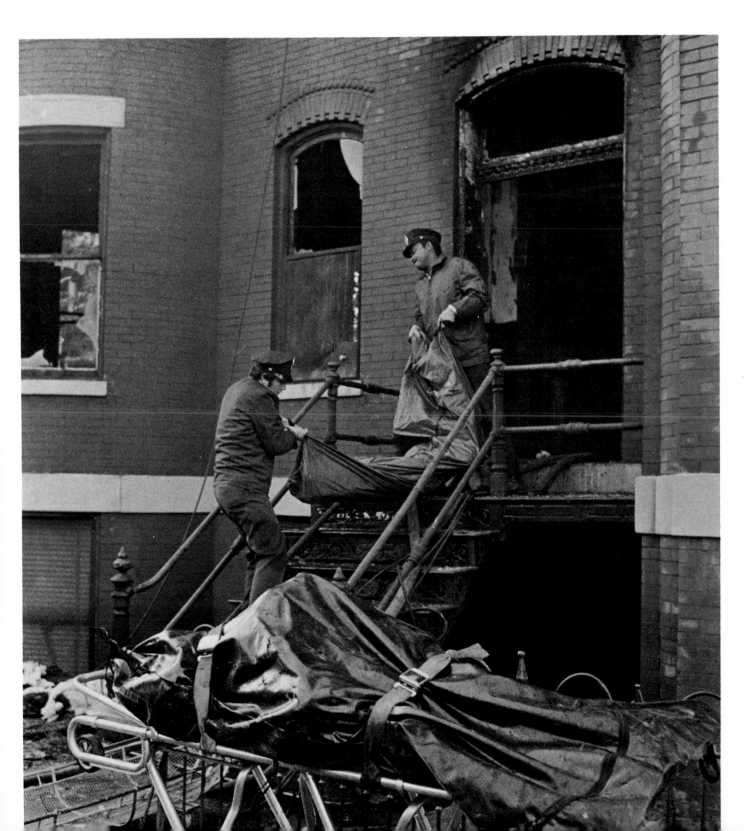

"Metro Stop"
Linda Wheeler
Washington Post

Feature
Class

"Strangers"
Peter Bregg
Associated Press

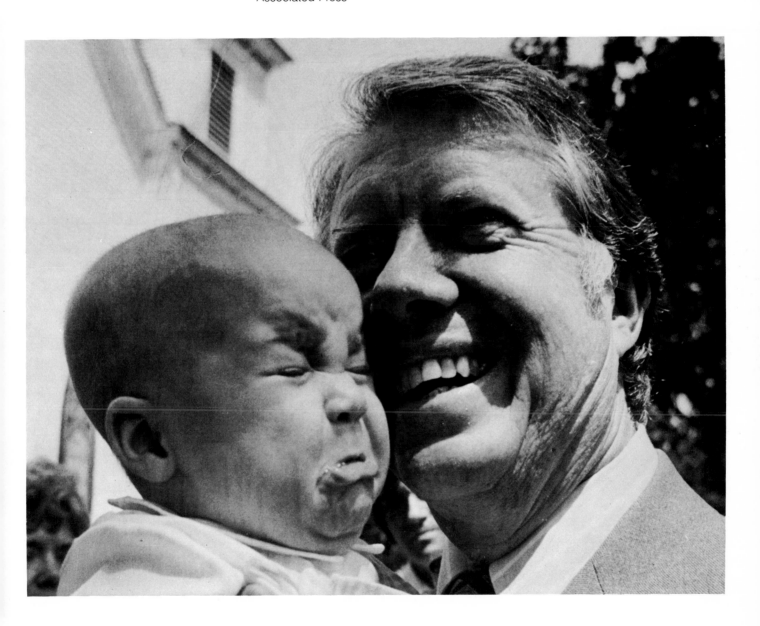

"An Old Time Story"
James Parcell
Washington Post

**"Agriculture Labor,
South Africa"**
James Blair
National Geographic

"Taiwan Roadbuilders"
R. Norman Matheny
Christian Science Monitor

"Freedom's Vigil"
Steven O. Fritz
Associated Press

"The 12,000 Foot Dives"
Emory Kristof
National Geographic

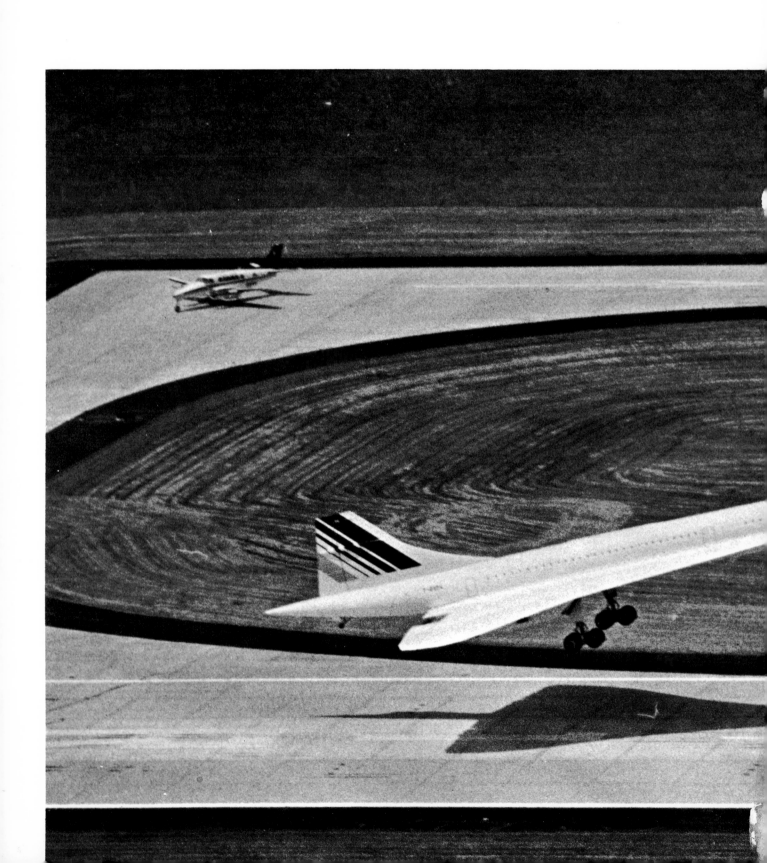

"First Landing"
Bernie Boston
Washington Star

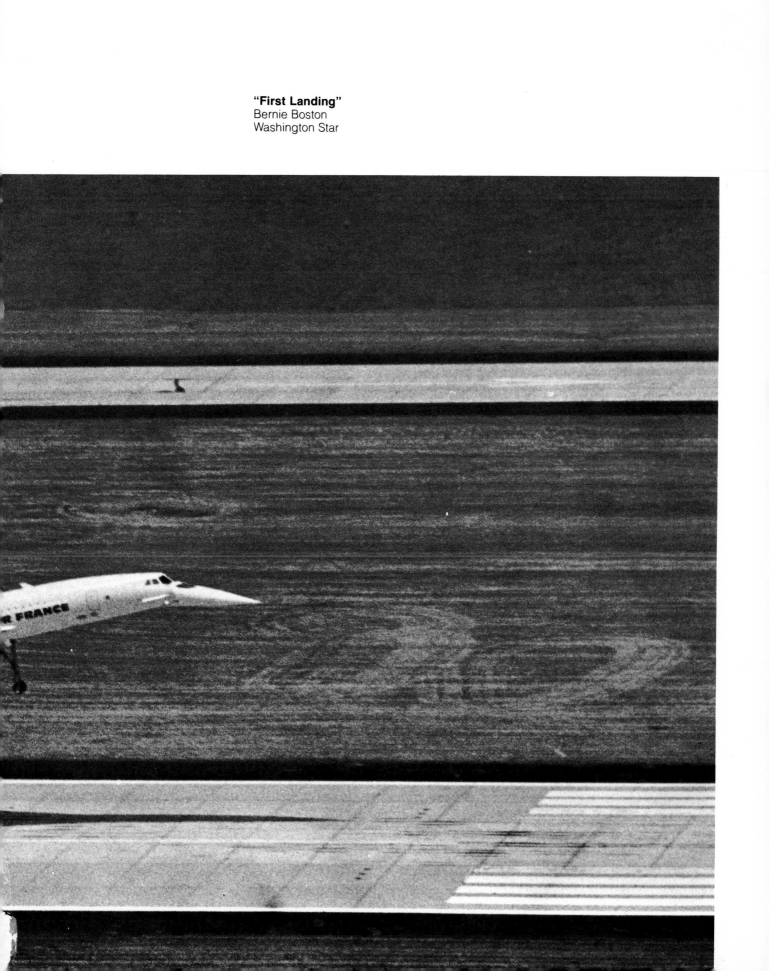

"Mother's Little Helper In Thailand"
R. Norman Matheny
Christian Science Monitor

Sports
Class

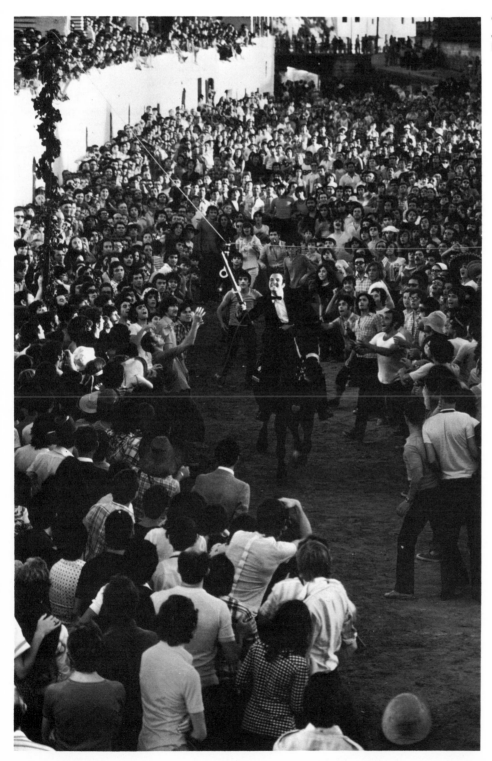

"The Jouster"
James Sugar
National Geographic

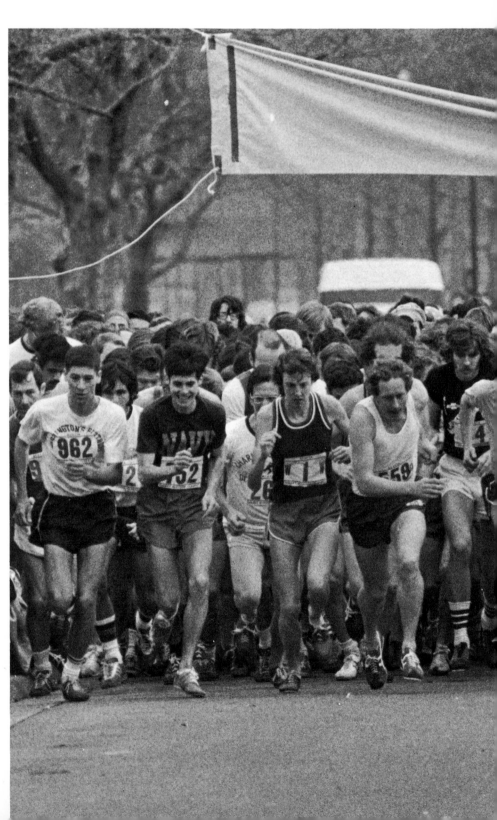

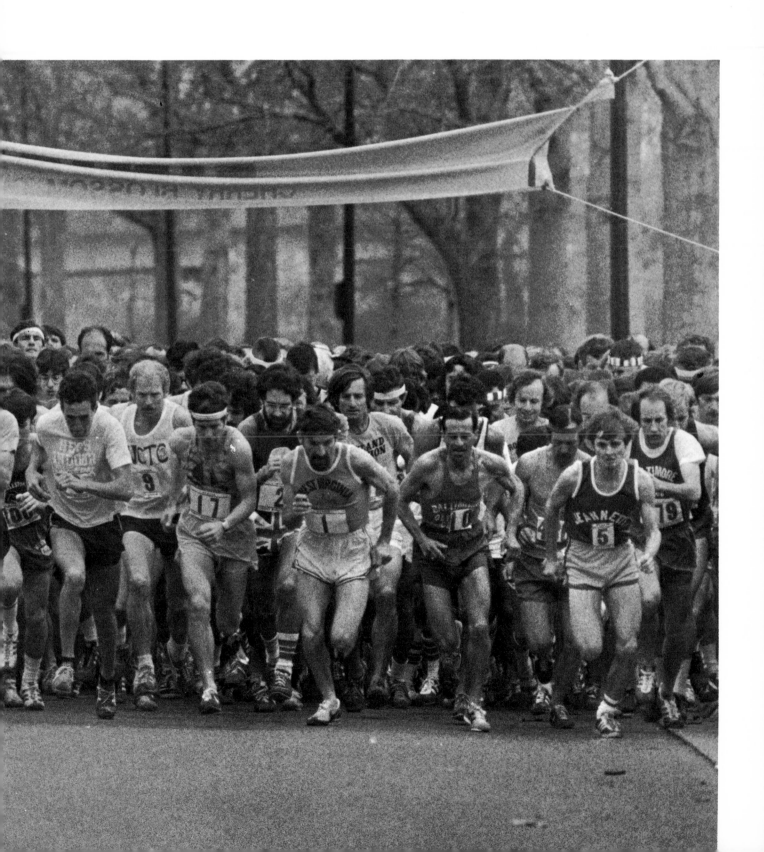

"BB Ballet"
Coleman Reed Tuckson
Washington Afro-American Paper

"The Art of Goalkeeping"
Richard Darcey
Washington Post

"Jimmy's Backhand"
Craig Herndon
Washington Post

The Techniques
and the Minds
Behind the Camera

The Techniques and the Minds Behind the Cameras

While the White House News Photographers Association has over three hundred members, many of them were across the world at press time in places ranging from the Arctic to South Africa and therefore they were unavailable for interviews. The comments on the following pages will bring the reader inside the minds and cameras of these distinguished professionals and provide an insight into the techniques applied to their works.

A cross section of the members of the White House News Photographers Association provides answers to these frequently asked questions:

- What was your most challenging assignment, and why?
- How were you chosen to be a White House photographer?
- What equipment do you carry and what was used for the winning shot?
- Do you spend the bulk of your time on assignment?
- What is the background behind your prize winning photo?
- Do you do your own darkroom work, on the job and at home?
- When and why did you get into photography?
- How much creative control do you have in your work?
- Did you face any technical or human problems getting your shot or in any of your work as a White House photographer?
- Do you see any technical developments in the present and future helping or hindering your work?

- If you had another chance to take your prize winning shot would you do it the same way?
- How do you feel women have been treated in the field? Have you come in contact with any discrimination on the job? (For women photographers)
- How do you feel women photographers will fare in the future?

In these brief eleven interviews, we record the extreme diversity within the White House News Photographers Association. As Bob Cirace, President of the White House News Photographers Association, says, "I'm sure you will agree that White House News Photographers Association members have done a masterful job of capturing these images. I'm especially proud of them and proud to be President of a truly professional organization."

"To be a White House photographer you have to be something of a technical athlete." A photograph should convey feelings, excite you. It should get the message across." "A photographer should love people." "Every assignment poses a new challenge, a new problem to solve." "To be a White House photographer requires a special attitude." These are just a sample of the incisive responses you will find recorded in this section of the volume.

The association represents news photographers, magazine photographers, TV cameramen, documentary cameramen and syndicated columnists. Some of these photographers were born to photography-oriented families; others began with cameras in their teens; still others showed no interest in photography until they took a photo course, a journalism course or an art and photography course in college.

A few of the photographers try to do all of their own darkroom work, and even go so far as to carry portable darkrooms with them on transcontinental assignments. Other members of the White House News Photographers Association have no time at all for developing their work.

The photographers take very disparate attitudes toward their work. One believes, "To be a White House Photographer is the pinnacle of the profession," while another claims, "All we do is take head shots of famous people." Their attitudes toward their work reflect the diversity of their backgrounds and the range in their training. These interviews gave us a chance to explore this diversity and to take the opportunity to share it with you, the reader.

Ronald T. Bennett
UNITED PRESS INTERNATIONAL

Ronald T. Bennett has been in Washington, D. C. since 1971. He enjoys working "at the center of all the action." Bennett chooses Nikon equipment for his professional work.

Bennett spends the bulk of his time out on assignment. He feels he can be as creative in his pictures as he wants to be with his camera but "it's another thing when an editor cuts the picture the way he wants it. Editors usually look for the bread and butter pictures before the creative, artsy ones. Everyone has a different style."

Bennett has been in every state of the union and even has been to Cuba. He says he probably flies 100,000 miles a year on Air Force 1. The advantage of this is "they take care of your luggage, something you usually don't have time to do."

He considers all of his assignments challenging. The White House, the Olympics and the campaigns where "you work ten to twenty hours a day with no sleep and little to eat" present special challenges. Bennett found the Robert Kennedy assasination a particularly memorable assignment while attending Portland State University.

"There's a lot of pressure when you're the only one on an assignment. They expect you to be three people in one. A local photographer just takes the film in. . We can't. You're the boss on the road."

Bennett worked in Los Angeles for three to four years and was on the *Oregon Journal* in college. In Los Angeles he covered sports, news and Hollywood. He does do his own darkroom work although he is busy. He shoots five or six jobs a day. He has experienced technical difficulties many times, such as never being close enough to get the shot you want, and trying to convince the Secret Service to let him get closer to his subjects. He feels that successful photography really depends on the advance people. "With today's advance people you can go anywhere." Bennett rotates his White House assignment with other U.P.I. photographers two or three times a week.

His advice to newcomers to photography is "become attorneys, doctors, or anything else, because the competition is fierce." However, he is convinced that the best photographers are in Washington, D. C.. "To be a White House Photographer is the pinnacle of the profession. It's a matter of the right place and time and contacts, and a certain knack for it." Bennett believes you need to build up to it and start someplace, like free-lancing.

Bernie Boston
THE WASHINGTON STAR

After receiving the customary Secret Service clearance, Bernie Boston joined the White House News Photographers and was assigned to the White House (in addition to his *Washington Star* duties).

Boston commented: "When you're new to the organization (the White House News Photographers) it's a big deal to be able to walk in and out (of the White House), but after three or four years it becomes just another place. You see the same thing over and over and it's routine." He feels that White House Photographers are at the mercy of the Press Secretary and explains that only a few photographers are allowed in to take pictures of an important dignitary. "It's a rat race," he added, "there isn't much room for creativity, not on a normal day. Even if a photographer has a special project, it still has to be cleared." He then explained the difficulty of keeping excitement in his shots of dignitaries. "If you're lucky and wise enough you can come up with something good. You try to get an animated shot, like someone yawning or pulling his ear, because otherwise they all begin to look the same and they all seem very static."

When a photographer gets accredited it means more than shooting at the White House. It also gets you into other parts of the government, like the Pentagon. "It's your government I.D. It gives you access. That's the value of it."

Bernie's interest in photography dates back to his high school days in the early '50's. He continued studying photography in his college years and has also worked for private industry and as a freelancer. His first newspaper assignment was the *Dayton Daily News*. Boston started there in 1963 and worked for three years. He has been on the staff of *The Washington Star* for eleven years.

Boston finds all of his assignments challenging. His most sensitive assignment was the story on Melinda, a young girl dying of cancer (picture story and article in this book). His most famous was the shot of a young protester placing a flower in the barrel of a national guardsman's rifle during a march on the Pentagon several years ago. Boston does get a special pleasure from photographing famous people and meeting them and talking with them afterward.

Boston uses the Leica system, feeling it's quieter than Nikon. However, he also uses Nikon for its versatility. "Selection of equipment is much less important than a photographer's attitude. People are the most important commodity. I dearly love people and I'm curious about them. I like getting . . . to see their lives and work. That's the most important thing about being a photographer. You must love people."

His advice to young photographers is to be "wary" of the profession because it is becoming increasingly hard to break into photojournalism. "Everyone thinks they're a photographer and that's not true. Education is important, maybe not for the number of degrees, but for the exposure. It broadens you. The academic environment exposes you to people, and that's important."

A good photographer must communicate meaning. "A good photograph should convey feelings, excite you. It should get the message across. If it doesn't, it fails."

Peter Bregg
ASSOCIATED PRESS

"The constant fear of being left behind is in the photographer all the time— otherwise it's pretty dull in Washington. D.C. I cover House committee meetings, press conferences and the Pentagon. It doesn't take a top photographer to take those kind of pictures. Ninety percent of the work in this town is made by set-ups —people standing here or there. The people come in, sit down, you take the picture, leave and send your film back with a motorcycle messenger because of a deadline."

Both of Bregg's pictures that won were made "unfortunately" by a 24mm lens because he was working up close. "When something is happening very quickly you haven't got time. I've learned my lesson. A star photographer will try to use the longest lens possible so they can get a good image and they don't have to blow it up. A lazy photographer will use the widest angle lens possible because all he has to do is point the camera and he'll get something." In the Billy Carter picture Bregg didn't want to be too obvious because, "Billy was trying to slug one guy for taking a picture already." Bregg says he shot it from the hip—aimed in the general direction and pushed the button. The Carter baby picture was taken outside a church with "hundreds of people," so to get a good picture "you almost had to be at Carter's elbows. There was nowhere for me to back up to use a different lens." But he still feels both of the pictures turned out well.

He uses a Nikon F-2 camera generally and he used it to take the award winning pictures. He does his own darkroom work, for his personal pleasure and sometimes on the job. "Both of the winning pictures were done in a portable darkroom. When a photographer is on an extended story, like the election campaign down in Georgia for months, you carry your own small darkroom with a transmitter. I was doing all my own souping, printing and transmitting."

Bregg has just started his two young daughters on photography. (They are six and eight years old.) Each has her own 35mm camera. A darkroom in the basement is handy for developing their pictures.

Bregg's advice to others just beginning is, "Take a lot of pictures and make a lot of mistakes. That's the only way to learn." He believes you can learn the physics and chemistry in school, but to be able to apply them successfully as a photojournalist "you must go out there and take pictures. Portrait and commercial photographers can spend days setting up a picture. They can plan the picture before it is taken, in contrast to the press photo which is taken before it's thought of." Bregg feels that getting the best possible picture out of each assignment requres the use of different lenses, cameras, papers, chemistries and techniques, since each one is a different situation. For example, working outside, at night, or with flash photography require tricks which photographers learn after some time.

"Any button-pusher can produce a picture that is usable but the fellows who come back with the better picture every time are the ones who have some working knowledge of the specialized techniques needed for each situation." Indoor flash, night football, inside and outside hockey are a few examples. Knowing which lens to use for each assignment is something you have to pick up on your own. It's nice to have someone to talk to about your pictures though."

Bregg learned as a copy boy with the Canadian Press wire service in Ottawa, Canada—taking pictures there "for the hell of it." The Canadian Press Service had one photographer who criticized Bregg's work and would go on assignments with him. Bregg would compare his pictures to those of other photographers and ask himself what he did wrong. "Things that were second

"The only creative control you have is behind the camera."

nature to him were in left field to me." After a while you make enough mistakes, and you realize what you should have done and next time do it right.

"Nobody gets a job with a good winning paper or magazine just because they walked in with a portfolio of pictures. They are usually known by the organization for a while if they free-lance in a certain area. That's how they get work. People who get out of school can't expect to get a job right away. You go out and free-lance for a while or be an apprentice. In this country of 220 million people, there are some 1700 daily papers alone and I don't know how many weeklies and magazines. There are a lot of photographers looking for work."

"When you look at most of the profession," Bregg says, "ten percent are considered quality assignments. Not everybody can say when they see a magazine, 'Well, I'd like to be that guy.' It's not always glamorous on the other side of the fence anyway. The grass is never greener."

Bregg worked in three different bureaus in three different cities and each had something to offer and each required a sacrifice.

Bregg does not find many technical difficulties in his work. "Most events don't scrimp when the President is involved. When you arrive at a photographic event it is well lighted. Nothing is too good for you." Lighting is done beforehand by someone who knows what they are doing. One human problem faced by the White House pool on the road, however, is that "everybody gets to eat except us. The press people can leap frog the busses because the President can get there much faster than they can. Time is set aside for the Press to eat, but the photographic pool can't eat, they have to be outside the President's hotel room, waiting for him. We can't just go out to a restaurant and order. We don't get the same service the President gets, so we're stuck." Now that Jimmy Carter has eliminated extras "such as food," the

photographers don't get anything. Bregg recalled the last trip he took with the President. "They served hors d'oeuvres for a meal while on the press plane they got steak and lobster. So coming back from West Virginia we got a bucket of fried chicken and passed it around Air Force 1." Since then, however, food has been reestablished on the Air Force 1.

A lot of photos taken on the road are taken with either telephoto or super wide-angle lens. "You're either too close or too far — you have to carry every lens in the bag, which usually weighs between twenty-five to sixty pounds. That's including four cameras, three motordives and eight to nine lenses, from 24 to 300mm. You could say the only technical problem I've found is with the equipment." The most valuable lens is the zoom lens, although Bregg says it is not well-liked by most photographers because quality suffers when you use the zoom. "When you cover the President the zoom lens is handy because everything is prepositioned. You stand at spot A and the President is at spot B. They march him in, he does his thing, they march him out again like a robot. You don't always have the opportunity to move in or back to accommodate the length of the lens." Bregg says that most photographers will take a wide angle and a 100mm along for an assignment but he wouldn't dare because, "you never know where you could be stuck. It could be in left field or under his nostrils," so Bregg brings all of his equipment.

"The sad thing about covering the White House and Washington is that here everything is done by someone else." In all of the other cities he was in Bregg did everything from the time the picture was taken to the time it reached the wire. He says there are four people directly involved in handling his assignment from the film to the wire. He feels you lose control. "If you're lucky you'll get one good picture that stands out from the rest and the person editing will print it. The editors will pick a picture they feel is suited to the story. They don't realize I had to stand on my head to get the other

pictures that I liked more." Bregg feels you have to strive for technical quality in the camera first because a few darkroom men may not compensate for a picture being too dark or too light. "The personal touch goes out, so when we make a picture we try to strive for quality so it won't be ruined by someone else. The only creative control you have is behind the camera. You have no choice but to shoot the standard stuff because that's what the editors want."

"We're not celebrities or stars. A contest winner doesn't make a good photographer. I've won lots of awards for pictures I thought were garbage and lost out on ones which I thought were good. I gauge a picture by how much play it gets. I made the picture of Ford slipping while we were in Austria and UPI missed it. That photo was front page around the world, yet when I entered it into the contest, it got beat by a feature I had done on Ford in Rome."

Photo contests he feels are a hit or miss thing. Whatever strikes the judge's fancy, wins. A lot depends on luck. "Some people seem to be luckier than others. My winning doesn't make me better than the rest. We're all very swell-headed and egotistic. Winning makes you strive to do even better. You've got to have a fat head, or a swelled ego in order to think you can do better. Think positive!"

"It takes talent. The good people will always surface."

Dean Conger
NATIONAL GEOGRAPHIC MAGAZINE

Dean Conger of the *National Geographic Magazine* has just finished a book of the Soviet Union, its land and people, called *Journey across Russia: The Soviet Union Today*. He has spent a lot of time there as a result of his work for *National Geographic*.

Usually out on assignment six months of the year, Conger has traveled the world: Java, Thailand, Japan, Scandinavia, the Mid-East. Conger has spent his eighteen years with *National Geographic Magazine* mainly on assignment out of the United States, and thus he's rarely around the White House for opportunities of presidential news photography.

He feels that it's very difficult to put a finger on any particular problems that exist in the course of dealing with people. "It is different everywhere you go. In Siberia (his award-winning "Siberian Village" appears in this volume) it's the cold," or, "it may be something else, like taking pictures from a plane."

Conger uses a Nikon for his photography and leaves the darkroom work to lab technicians. His photography began as an elementary school hobby, continuing through high school and into college, where he began his work for the *Denver Post*, a job which lasted nine years.

His advice to other people entering the photographic field: "Don't. It is a very narrow field (magazines especially) and the competition is high. You need to be really good to make it. The good people will always surface." It is more than being in the right place at the right time. "It takes talent."

Bruce Dale
THE NATIONAL GEOGRAPHIC MAGAZINE

Bruce Dale has been a staff member of the *National Geographic Magazine* for thirteen years. He finds every assignment a challenge. Dale generally uses a Nikon system and switches to Canon and Olympus for specialized work. He does ninety percent of his work with two cameras and three lenses.

Dale feels the most important thing in taking pictures is to be "honest." He doesn't like setting up a picture. "I'd much rather be around someone for a day or two and try to capture a moment. That's what happened with the Ford and Liberty picture. It was a moment which was not planned but was just there." Spontaneity also characterizes Dale's "Shorebirds" photo. "Shorebirds" was photographed on an assignment about Magellan. The Ford photo was local — it represents only one day's worth of effort. The Magellan story took four months, and it involved retracing the route around the world. "In an assignment like Magellan I keep trying to relate to the past. It could easily take ten years to complete unless you have specific points to look for." Dale used a journal from a man who traveled along with Magellan and managed to return. He chose items from the journal as he researched the subject before he photographed the story. He noticed a preoccupation with sharks which eventually led him to a tiny village of shark fishermen along the northern coast of Uruguay, where he shot "Shorebirds." The village was quite a find for Dale as he shot more good pictures there in a day and a half than he usually shot in weeks.

Dale's greatest technical challenge was taking photos from the tail of a jumbo jet in flight. These pictures required the complete cooperation of the flight crew, airport ground administrators, personnel, and aircraft manufacturers. He had to check the altitude, flight speed, temperatures, and dynamic stability in order to determine the parameters the camera must operate on. Dale found other kinds of challenges in the overall

"Assignments can be challenging both technically and physically."

scope of coverage required for his books on the Gypsies and American Mountain people. He strives for variety in his selection of subjects. "Really the most difficult part of an assignment is trying to allocate your time. It's so easy to get carried away on things which become a waste of time. Assignments can be challenging both technically and physically. Most of the photographers on the *National Geographic Magazine* have worked on physically challenging assignments. I've worked hundreds of feet under water to thirty-five thousand feet in an open plane, and from minus 60° in the Arctic to 105° in Washington, D.C."

Dale has a little darkroom at home for his own pleasure. Dale feels that automation has caused vast changes in photographer technology. "Technically, photography has become much easier in the past few years and the quality is higher. The automatic cameras actually work quite well and they enable us to capture moments that might otherwise have eluded us. Twenty years ago photographers had to work to make a technically good photograph. Today automation allows almost everyone to go out and take pictures. I can give a camera to an eight year old and have him come back with sharp, perfectly exposed photos. You couldn't do that twenty years ago. But even though anybody can learn to use equipment the difficulty is teaching them to 'see' pictures. I think you can see the photographic potential in a person simply by his or her taste in pictures. Some people just don't know a good picture when they see one. They can't tell if it has impact, feelings, emotion, or balance, or if it has a message. Conveying these qualities is what photojournalism is all about. Almost anybody can learn the technical part."

Dale started photography early during one summer vacation from high school. He and a friend took a book out of the library on the developing of prints. They took a roll of film his mother had shot, developed and ruined it. "We developed it under red light when it should have been developed in total darkness." Dale was thirteen at the time. After returning to school in the fall, a teacher who was somewhat advanced in photography gave him more advice. By the time he finished high school he had fifty-five pictures published in Cleveland papers and he had compiled a good portfolio. Dale worked on photography throughout high school. His portfolio allowed him to get work in a portrait studio, a camera store, and finally a newspaper. He spent all his summers in Cleveland and attended many journalism seminars at various universities. After seven years on the *Toledo Blade* newspaper he was asked to do one or two pictures for *National Geographic Magazine*. "It was a short assignment — to get a picture for a story." Finally, he was asked to do a story on St. Louis. He worked on it during his un-paid vacation but found himself unable to complete it. *Geographic* then offered him a full-time position which he accepted. That was thirteen years ago.

Dale recognizes the importance of both education and experience. "Both are important although I'm not sure I'd recommend photo-journalism school. Sometimes I think whether a background in anthropology or sociology might be more helpful." Dale recommends courses in art studies and courses which train you how to deal with people. He feels that the kind of education selected should relate to the kind of photography one wishes to specialize in. "The technical aspects of photography can be picked up without formal education. But, I'm talking about photojournalism. If one wanted to specialize in commercial photography, like in large format cameras, it might be better to go to a school."

"Get a job on a small-town paper"

John Duricka
ASSOCIATED PRESS

John Duricka was transferred to Washington, D. C., from the New York bureau of the Associated Press by the choice of his senior editor, and has been with the White House for eight years. Many of his earlier assignments in the Nixon administration had him traveling to Moscow and to the SALT talks, which he found very challenging.

Duricka usually can count on 98 per cent of his pictures being published somewhere around the world because of the wide coverage of the Associated Press.

He doesn't really find any problems in working at the White House: "The press staff works very closely with the photographers in the course of their work, helping to arrange set-ups or posed shots."

The biggest human problem he has faced thus far in any of his assignments is in dealing with the foreign press and getting to know the ins and outs of another country.

His standard equipment is Nikon, which he used in his winning photographs and on all his assignments.

The advice Duricka gives to those intent on breaking into the field of photo-journalism is straightforward, "Get a job on a small-town paper. You've got to work on up through the system."

"Equipment and film are fairly sophisticated now, and it's up to the photographer."

Gilbert Grosvenor, Editor
NATIONAL GEOGRAPHIC MAGAZINE

While in Bermuda checking on three stories for *National Geographic,* Gilbert Grosvenor stowed away on the photo plane and took some snapshots, one of which won him the award in the News category. He hasn't had a photographic assignment for over a year. Working as an editor doesn't give him the opportunity to leave his desk very often.

Grosvenor has been experimenting with a variety of cameras but still prefers his Nikons. Although not able to get out in the field for photography very often, he does make a number of editorial surveys. Grosvenor has been an editor for seven years and worked with the *National Geographic Magazine* for twenty-three years. He came straight from college to *National Geographic* after taking photographs as long back as he can remember. His first assignment was one on Holland. He continues a long family tradition of interest in photography.

Gilbert Grosvenor recalled his work with former President Eisenhower on his first international diplomatic trip to Europe, Asia and Africa as his most challenging assignment. He was on a three-week assignment as a writer/photographer for *National Geographic* on that trip. He found it both technically and humanly challenging.

Grosvenor advises potential photographers to "start early, start young, and start small. Experience is extremely important in photography. College education is important too — but if possible, aspiring photographers should try to shoot photo assignments for a local paper or school publication as early as possible. The earlier the better, the more exposure the better. It's very difficult for a photographer to break into a major publication today without having extensive experience on a smaller publication."

As editor for the magazine, the qualities he looks for are creativity, editorial judgment and sense of composition. He feels a good photographer must have an "eye" for photography. "I suppose a certain amount of that is born in you. But any person with a reasonable amount of talent can work with his potential and sometimes achieve more than the person who has tremendous innate ability but might not have the drive to fulfill his or her capacity. Drive and determination are VERY important attitudes in the photographer. I don't care how successful a professional may be, if he or she is not highly motivated on any assignment they're going to flop."

Grosvenor is convinced that modern camera technology has opened the way for creative expansion. "The constant improvement in equipment and film has been responsible for tremendous opportunities for photographers to extend their creative range in the last fifteen years. I question whether this pace of technological break-through is going to continue. I think we may have reached a point where the individual photographers will have to exert themselves to improve the state of the art. After all, equipment and film are fairly sophisticated now, and it's up to the photographer to utilize that equipment to its ultimate design."

Susan McElhinney
NEWSWEEK

Susan McElhinney and Wally McNamee share the responsibility in the *Newsweek* bureau in Washington, and they do just about everything. McElhinney has been with *Newsweek* since November, 1975. She didn't come up through the ranks like many of her co-workers in the White House Photographers Association she free lanced for a while making her own breaks without the usual small town newspaper experience to back her up.

McElhinney's published output depends on the selections of the editors. She has two direct competitors, Associated Press and United Press International; all fighting for the best shot in a subject area that tends to remain about the same, day in and day out.

The most challenging assignment she has had to face to date was the Carter campaign. McElhinney said she hasn't had many technical problems throughout her career although "photography is basically a technical profession." You have to be something of a technical athlete being in the right place at the right time with the right gear." McElhinney feels the greatest human problem she has faced thus far in her career has been "getting anything straight with the White House press office."

Some people feel that photojournalism work allows little opportunity to be creative but McElhinney believes "creativity is the perception of what I see in the camera, though that can be sometimes limited. How creative a picture is results from what I see in the camera." She does not process any of her own photos.

McElhinney likes the people she works with and finds no evidence of any discrimination toward her in the office. When she tried to break into the business, she ran into problems with those in the upper echelon, however — the editors and decision makers. "The main problem is to get anyone to take you seriously. The people who own and run the operations are less willing than the people who work for them." However, McElhinney finds the White House photographers very gracious and very responsible. "They are a real bunch of pros and much more."

Ms. McElhinney's advice to anyone trying to get into the field of photo-journalism is "to have no great illusions of a marvelous job. It is very hard work. People think of the playboy photographer with the big expense account, but he doesn't exist. Most of the White House photographers are really just glorified head hunters. Taking head shots of important people. That's all it is."

"The Big UPI Father in the Sky tapped me on the shoulder one day and said, 'Come, Boy, we want you.'"

Tim Murphy
UNITED PRESS INTERNATIONAL

Tim Murphy spends most of his time on assignment. He uses a company-issued Olympus but he "can't stand it—they're garbage." The photographers had been using Nikons two years before but those were taken away.

"There are five people in the office who rotate over to the White House on a monthly basis. Those who are on shift at the White House can go on any trips that may come along, and recently I got a chance to go to South America with Mrs. Carter. You get those trips once in a while. Everybody gets a crack at them.

"My most challenging assignment is hard to pinpoint. Possibly the period around the Watergate thing, specifically from the time the articles of impeachment were returned by the House Judiciary Committee in the summer of '74 to Nixon's resignation in August. We were all working pretty hard during that time.

"As to the picture that won, it should have won first prize. It started on a memorial march. I just followed along, not in the photo truck, but walking beside. I went ahead a little and prepositioned myself. It was a spur of the moment picture. We didn't know they were going to do that. Half the time it's just luck. Your opposition, either the locals or Associated Press, could be three feet to the left or right and not get the same picture. A lot of times it depends on the angle from where you're shooting. It helps to have the right lens on at the time that it's happening. It also helps to have film in the camera too, I guess."

He started playing with photography during elementary school; made pictures all through junior high and high school; got a job on a local paper; then to college for a while and worked for more papers until "the Big UPI Father in the Sky tapped me on the shoulder one day and said, 'Come, Boy, we want you.'"

To him it doesn't depend on what kind of education you've got, it depends on what kind of pictures you make. "Whether education can help you or not—the photo theory, chemistry and that stuff is all well and good, but I think the company would have hired me one way or another even if I hadn't gone to school. And there are a lot of people who've never gone to college and they got hired. It doesn't really make any difference. All they want to see is your tearsheets and your portfolio. It doesn't matter what you did before you came along with them. I'd say go to school and learn the basics; work with color. I went to school in Rochester and worked for Kodak and for some professionals up there, in the studios with a view camera, but I've never had to use anything I learned in school on the job. I've never had to use the techniques with a studio view camera because we don't do that kind of work."

His advice—"It's very difficult now to get in because anything related to journalism everybody wants. Everybody wants to be a reporter or photographer. There are a lot of newspapers that are now paying better than the wire services. My suggestion to anyone young and starting out is to get a job on a good-paying paper because actually you get much better exposure. You've got the time to go out and shoot features, and if you've got a paper that's picture-oriented, you can get a picture page. The paper I worked on in Florida was that way. You get three or four pictures on the back of the front section. Newspaper photography and wire service photography are the difference between day and night because in wire service work we've got to tell the story in one picture, we don't have the display room to tell the story. The competition is pretty stiff, especially in Washington. In the wire service it's not just making pictures. Here at U.P.I. in Washington, we have to do everything: we read the wire, write captions, print and develop. We do have people to do this stuff but on weekends the photographers do everything. The other bureaus seem to work the same. In wire service you've got to be a jack of all trades.

"As for human or technical problems, nobody in this administration knows what they're doing. They're terrible. I've been through three administrations and this one's the worst, without a doubt. We just had a situation here recently where microphones were coming from all directions at Carter; technicians and reporters in the way of the photographers. They permit 'wild sound' over there. Ford and Nixon didn't. We're making pictures of one another. It's just terrible and these people don't seem to care. If they did away with the sound it would be better. People wouldn't have to come up and stick microphones in front of their faces.

"Technique-wise the day will come when we go to the same thing the networks are doing with small tape cameras. Instead of shooting the film and developing it and printing it, we'll just have a small camera that shoots the tape. Then we'll edit it in a tape viewer, press a few more buttons and put it into the computer in New York, and let the clients decide what they want via our new method of news delivery, VDT (Video Display Tube). They can call up any story they want and see what pictures are available. But this is maybe ten years away. Anything would be better than these Olympus cameras.

"You can be creative only if you have a specific assignment. I had one for the *Chicago Tribune* on the Eastern Shore when Princess Anne was here in Centreville, Maryland. They wanted a layout on the town. It was actually fun to make pictures again because I didn't have to show Princess Anne in every picture. I could show a kid holding up a Union Jack or an old person leaning against a parking meter—that kind of stuff. When you get the chance you're creative, but we don't have that opportunity often. We can't move a picture from Centreville without Princess Anne in it. As far as Washington goes, the standard rule here is you don't move any picture out of Washington unless it has some identifying landmark. The locals can go out and make a feature picture and it doesn't matter if it has the Jefferson Memorial or the Washington Monument in it or not. I don't necessarily agree with this but I don't make policy."

James Stanfield
NATIONAL GEOGRAPHIC MAGAZINE

James Stanfield has been a staff member for *National Geographic Magazine* since 1965. His interest in photography started very early in his life, encouraged by his father and uncles who were very involved with photography. His father worked on the *Milwaukee Journal*, and so he had the opportunity to watch his father at work. Stanfield was mainly interested in art, though not in the professional sense, before the photography bug bit him. "I was just interested in creating something."

After he entered college he took some journalism courses in photography and discovered he really enjoyed it. "I was intrigued by the things my father had done and seen and the things he was exposed to — all the beautiful old classics of many moons ago taken with flash powder and glass plates. I liked that variety and exposure."

Stanfield entered an art school immediately after graduating from journalism school, and later was drafted into the Army which sent him to photography school. After receiving his discharge he applied for a job on the *Milwaukee Journal*, but with no jobs available he went instead to work at a factory to raise enough money for a camera.

After a stint with a commercial illustrator in Chicago, his job at the *Milwaukee Journal* materialized in 1960. Later, he went to work on the *Black Star*. In 1965 he began to do freelance jobs for *National Geographic Magazine,* and in January, 1967 the *Geographic* asked him to become full-time.

He had worked previously on his own with color, which the *Geographic* considers standard fare. He accepted the job gladly. "I wanted it so bad I could taste it." Stanfield has reached a point now in his career where he feels he can accept compliments on his work. Previously he felt he wasn't getting close enough to the subject, either with a person or country.

"I don't feel self-conscious any more in documenting people and getting closer to them. At one time I felt awkward or thought I was being rude. But people respond in the same way, they feel you're a professional, that you've done this before. You tend to become well-rounded. People are no longer satisfied with a portrait of a person or place. They want to study a person and know him."

His most challenging assignment was doing a story on gold around the world. "My life changed an awful lot on that story. I learned a lot from a guy also assigned to the story as a writer, Peter White. I feel he was one of the best writers and researchers I have ever worked with. He is a true reporter. This story was the start, and then everything began becoming more complicated and complex. This happens when you demand more and more of yourself."

Probably one of the most difficult assignments for him was a story on the Potomac River that took him three months to complete. He tried to cover it the same way he had covered a previous story on the Mississippi River but soon discovered he couldn't do it that way.

"The Potomac is different; it lacks romance. The Mississippi had Mark Twain; the Potomac has no one like that. So I went deeper, into the people living along the river. This wasn't a choice assigment but I learned a lot from it." He put pressure on himself because, "I knew the editors and the people looking at the pictures would be familiar with the area and I really wasn't. I don't stay in this area very much." All his fears dissipated with a response of approval from his co-workers, an approval which meant much more to him than any praise received from the public.

One story he found technically very difficult was a story on rats around the world. "Everyone's always got rat stories to tell but there had not been much documentation in the past on rats."

Thinking back over the stories he has done with the *National Geographic*

Magazine, Stanfield believes they are more people-oriented than anything else. "You always learn something. You have to expose yourself to the subject as much as possible. That's the only way you can do it."

He thinks a quality photographer must have sound technical ability but, "It should come like driving a car. It should all be second nature, so you can devote your time and respond to the situation. A photographer has to have a certain awareness of life. You find yourself studying people and situations and you should be sensitive and sympathetic. There is a certain amount of inborn ability, but one must work at that ability, make it grow. Watch how people live, watch how they suffer, watch how they cry, and how they laugh and enjoy life, too. Watch everything that goes on."

Stanfield feels school is a great foundation for photography. "Everyone should go to school to further their technical ability so it all becomes automatic. The more variety, the better the foundation, the better off you are. The best thing is the attitude. I'm not saying be a fanatic or devote your whole life, but it certainly helps."

A story he just completed on Japan had him working harder and devoting more time than ever before. "I don't know whether it's ego — but I enjoy work. My entire life is composed of work, whether it be in the garden or taking pictures. I'm a driven person. You have to have the attitude that I'm going to go out and look at this country from 4:30 in the morning until the sun goes down at night. You make your own luck and you learn something every day. It comes pretty slowly and you think, is it really worth it? But when it starts, it comes well."

The equipment Stanfield carries is the Leica system, though he still has a full Nikon system as well. Approximately 99 per cent of his pictures are taken with the Leica. He was introduced to the brand in 1970 when he won a Leica camera in another White House contest. He compared it with Nikon and found it was

"If someone wishes to learn, they'll always learn. Talent is instinctive."

a bit better, sharper, and the lenses were more brilliant. He had used Nikons for ten years.

Stanfield considers the new electronic cameras with the automatic shutters the development most likely to change the way pictures are taken. He feels it can solve a lot of technical problems for photographers. "I'm not much of an electronic bug. I use mostly older equipment, but I'll try the automatic cameras because the system can take care of itself. It involves less thinking of the operation of the camera so you can continue to study the subject. It gives you more time to spend with the subject.

"Not many people in the world have a job like I do. I get a lot of rewards from this job and I enjoy it greatly. I can come home and be tired, but it's an enriching tired, a great tired, because I accomplished something I've enjoyed doing."

Teresa A. Zabala
THE NEW YORK TIMES

Terri Zabala who has been with the Washington Bureau of *The New York Times* for two years usually works with a Nikon but prefers Leica for her personal use. Her award-winning shot of President Ford ("It's All Over Now" — First Place, Presidential Still Category) was taken with a Nikon.

Terri explained that covering the Ford campaign was her most challenging assignment to date saying: "I had never covered and traveled on a campaign before. I enjoyed it. It was a unique experience, but I was glad it doesn't happen every year. It was all physically exhausting." Although it was draining physically and mentally, Teresa is grateful for having had the opportunity and experience.

A White House Photographer has to go wherever assigned. Since Terri spends most of her time covering the White House she finds it "confining." There is the same difficulty any photographer finds getting a good shot. "You don't walk around the White House and trip over good photographs." She feels a photographer has to seek out a truly great photograph.

"In my career, at the beginning, there was some discrimination." She finds that things are quite different from when she began fourteen years ago. "There are now two women on *The Washington Post* and one on *Newsweek*. Washington has adjusted to women photographers pretty well. There are certainly good women photographers around town." She sees further improvements coming and says: "The more accomplished people are, the more anxious people will be to hire them. People will hire talent when available and, if you can beat somebody on talent and not just on the way you were born, for heaven's sakes, that's what matters."

There have been enormous technological developments in the recent past, but many people, including Terri, prefer to stick to old favorite equipment. "Lots of equipment is becoming smaller and lighter. They're always coming out with something different. But old lenses become favorite ones after a while." Most of the recent technological improvements have been in the area of lighting — especially strobes, and Terri feels that these developments in lighting have been critically important. The speed of modern technology is vital to her since the darkroom she works in out of Washington transmits directly to New York and "it gets hectic with a 5:15 (P.M.) deadline every day."

Teresa Zabala graduated from UCLA where she was an art history major but took some courses in photography and decided to continue with it after studying at Art Center School for only a year. "A college degree doesn't make a photographer. If someone really wishes to learn, they'll always learn. Real talent is instinctive."

Photography: and Approach

"Photography is not about cameras, any more than drawing is about pencils."

Taylor Gregg

Taylor Gregg, Picture Editor, National Geographic Magazine, teaches Photojournalism at George Washington University and has for several years run his own workshop in Photography as Fine Art. He also is co-sponsor of the American Visions workshops at American University, which bring together working photojournalists and area Fine Arts teachers for a series of discussions and student critiques.

Although the photographs shown in these pages were made by a few highly skilled and talented photojournalists, their photographs are part of a much larger world which belongs to all of us. The language they use is symbolic, older than speech, and in their art they mirror and record our existence. They make it possible for us to see ourselves, and sometimes even to understand ourselves, and that is their profession.

It is hard to believe that the handful of men whose discoveries gave birth to photography would be other than dumb-founded at what it has become. But the same is true of those who are involved in this still infant art today. We, no less than strangers to the passion, are often perplexed by the simplest of questions. To a mere beginner it must appear he is approaching a cross between popular mechanics and a vast mystical religion. Of course this is exactly the case, and he is wise to be wary.

Photography today is threatening to become all things to all men and women, and why not? We already know from McLuhan and even our own senses that we have arrived in the age of the visual image. And Alvin Toffler in *Future Shock* noted that the speed of events is now much too fast for anything less than one thousandth of a second. And did ever any medium claim so much? A recognizable image practically guaranteed on the first try and the presumption to Art at the same time. And the machine itself for only $8.99 plus film.

But the camera is unique in communications history, and its impact more shattering than anything since the advent of written language. Fortunately a beginner can sidestep all the heavy philosophy and just start taking pictures. The shutter does not ask why you push it, although some electronic cameras will question your choice of f. stops.

The camera is first of all a machine, and for many that is enough. It is enough to make them buy great amounts of equipment (camera, lenses, etc. etc.) and then whole libraries of books which explain how to use the equipment, and finally in some cases, to enroll in special schools run by the manufacturers of the equipment. To gain some perspective on this behavior you might substitute, say, a Hoover vacuum cleaner for the camera, and see how it sounds. Oh, I know the vacuum cleaner can only clean your house while a camera can . . .

But it really can't; not until you reach the point where you can forget about the equipment and become involved with the image. So photography is not about cameras, any more than drawing is about pencils. In the choice of your own equipment, it is good to remember that less is more, particularly in the early stages of learning and where no professional requirements are being made on your work. Use a larger format if you want detail and formality, a smaller one if you want to be unobtrusive and quick.

The photographer can of course be anyone, and that is really the good of it. Only the tiniest percentage of those millions involved in photography will ever make a living at it, and few of those who do will eat well. Photography is largely an amateur activity, and although there is a great deal of snobbishness about professionalism, there is no evidence that those who are most eager to use the label fully understand the game.

But assuming you want to get more out of photography than a preoccupation with mechanical devices, even as a writer desires more than an affair with a Smith-Corona. Then you have to risk the big question: What is Photography?

Presumably everything we do — speech, body movement, dress — is an act of communication, an expression of self. The need to experience oneself; to say "I am" by communicating with others is universal. No desire, no wish of mankind is more ancient, or more tortured than the pursuit of self-knowledge. The attempt to "know thyself" has been the preoccupation of man throughout his existence. The historical quest for self-knowledge comes from two basic ideas:

1. To understand oneself is to gain control over oneself, and ultimately one's life.

2. There is a direct link between the individual self and the cosmos; to gain knowledge of the individual will also explain the cosmos, and vice-versa.

The reward is a state of understanding or enlightenment and the personal sense of peace it brings.

So, formal art aside, all men and women create in order to know and be known. However, because we are not altogether certain of our reception were we truly to be known, we also frequently create to avoid being known, exerting great amounts of energy toward deception. And every attempt at communication is a mixture of these conflicting desires.

"The indiscriminate machine joins with the very discriminate photographer to make a photograph."

When you take a camera into your hands you hold a mirror up to yourself, and in the process you become more consciously involved in the struggle to know yourself and to have others know you. The camera, for all its wondrous technology, is totally undiscriminating. It sees everything and comprehends nothing. It is your willing servant, ready to reveal or obscure at your command.

The process itself is painful. Our own eyes, marvelously intricate machines themselves, do not see very much. So much is happening so fast that we have tuned out in order to have peace. Our visual landscape is so cluttered with the graffiti of daily life that we must avoid focusing, and we do. And because the camera more than any other medium must use this chaotic landscape as speech — as verb and syntax — a photographer must learn to see anew.

Photography steals moments from time, holds them back, keeps them from leaving us. And in every subject, every act, there is a moment when all the elements come together in a relationship that speaks for the whole act, the whole idea. So the indiscriminate machine joins with the very discriminate photographer to make a photograph.

And by what authority do you discriminate? At first, of course, you imitate and copy that which will express your taste, but in cliché. But to get beyond the cliché you have to accept the fact that your view of reality is both unique and valid. Then you can make a photograph.

In photography, reality is your vocabulary and the camera your means of selecting just the right words for your message. To the degree, then, that you are willing to use the camera to explore yourself, it will express you, and communicate with others. It is a life-long process, promising great fulfillment and no little anguish. In our age, there is nothing else like it. Who could ask for anything more?

WHNPA Members

Gene Abbott
Thomas J. Abercrombie,
 National Geographic
Steven C. Affen, WMAL
Tom Allen, Washington Post
Murray Alvey, ABC
Jay David Alvey, WRC
James L. Amos, National Geographic
LeRoy Anderson, NBC
Britton M. Arrington, Jr., WTOP
James Atherton, Washington Post
Robert Baer
Elwood Baker
J. Bruce Baumann,
 National Geographic
William C. Beall
William H. Benedict, Sr., NBC
Nathan Benn, National Geographic
Charles W. Bennett,
 Associated Press Photos
Ronald T. Bennett, UPI Newspictures
Walter E. Bennett, Time Magazine
Lewis H. Bernhardt, NBC
John Bessor, CBS
Milton D. Bittenbender, CBS
James P. Blair, National Geographic
Kenneth L. Blaylock, ABC
Bernie Boston, Washington Star
Victor R. Boswell, Jr.,
 National Geographic
John Radford Bowden, Jr.,
 Washington Star
David S. Boyer, National Geographic
Robert D. Boyer, WTOP
Peter A. Bozick
William D. Brack, Black Star
Peter M. Bregg,
 Associated Press Photos
Francis Brewary
Robert H. Brockhurst
Robert Burchette, Washington Post
*Henry Burroughs,
 Associated Press Photos
Frank Cancellare, UPI Newspictures
Al Candido
Victor Casamento
Edward H. Castens,
 U. S. News & World Report
Douglas Chevalier, Washington Post
Robert H. Cirace

Edward H. Clark
William James Colton
Dean Conger, National Geographic
Paul S. Conklin
Dennis A. Cook, UPI Newspictures
Clarence H. Copeland
Thomas J. Craven, Jr.
Willard E. Culver
Bruce A. Dale, National Geographic
Karen Colodne Danahar
George Danor
Richard G. Darcey, Washington Post
Robert A. Daugherty,
 Associated Press Photos
Ellsworth J. Davis, Washington Post
Jean Guy DeLort,
 Fairchild Publications
Charles G. DelVecchio,
 Washington Post
John M. DiJoseph, Reni Newsphotos
Thomas V. Dukehart, Jr., WTOP
John Duricka,
 Associated Press Photos
Richard S. Durrance II,
 National Geographic
Arthur J. Ellis, Washington Post
Kenneth B. Feil, Washington Post
Charles Fekete, NBC
Sheldon Fielman, NBC
Nate Fine
Paul R. Fine, WMAL
Vincent A. Finnigan,
 Washington Films and
 Keystone Press Agency, Ltd.
John E. Fletcher,
 National Geographic
Gary P. Fookes,
 Hearst Metrotone News
Benjamin E. Forte,
 Consolidated News Pictures
Russell T. Forte
Donald Ray Fox
Betsy K. Frampton
Charles V. Franks, CBS
Roland L. Freeman, D. C. Gazette
Thomas J. Freeman,
 Wide World Photos
George J. Fridrich, NBC
Robert Fromm

John E. Full, UPI Newspictures
Robert F. Funk
Gordon Gahan, National Geographic
Wilbur E. Garrett,
 National Geographic
*George R. Gaylin
Norman Gaines
Robert H. Gelenter, NBC
Harvey Georges,
 Associated Press Photos
Eugene J. Gerlach, CBS
Geoffrey David Gilbert
Robert E. Gilka,
 National Geographic
Edward M. Gilman, ABC
Benson N. Ginsburg, WMAL
Julius Eugene Glover, Jr.,
 Afro-American
Harry Goodman, Washington Star
William J. Gorry,
 Associated Press Photos
Bernard T. Gmiter, WMAL
George A. Grant
Robert Grieser, Washington Star
*Henry L. Griffin,
 Associated Press Photos
Gilbert Grosvenor,
 National Geographic
Peter J. Hakel, WMAL
Dirck Halstead,
 Time Magazine
Chick Harrity,
 Associated Press Photos
Joseph Heiberger, Washington Post
Darryl L. Heikes, UPI Newspictures
Donald L. Heilemann
Kenneth R. Heinen, Washington Star
Robert H. Hemmig, ABC
Lawrence Herman, WMAL
Craig Herndon, Washington Post
Charles A. Hdagland, NBC
Bruce G. Hoertel, CBS
John Hofen, NBC
Harold Hoiland, WTOP
Louis J. Hollis
Gordon Hoover, ABC
Charles H. Horne,
 Alexandria Gazette

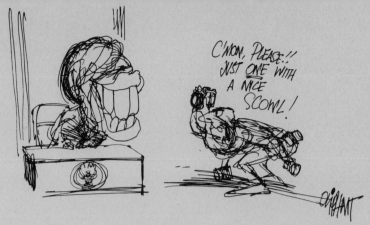

C'MON, PLEASE!! JUST ONE WITH A NICE SCOWL!

Richard A. Horwitz,
 Associated Press Photos
Frank Hoy
Thomas L. Hoy, R.E.A.
Ralph Huttenloch
William R. Huttenloch, WTTG
Nour Runa Cl. Hzyan,
 N.E.W.S. Photo-News Worldwide
Otis Imboden, National Geographic
Joseph D. Jamieson
Arthur W. Janes,
 Associated Press Photos
Henry Jenkins,
 Associated Press Photos
*Hugo C. Johnson
Maurice Johnson,
 Senate Press Photographers Gallery
William R. Johnson
Frank B. Johnston, Washington Post
Louis G. Johrden
Robert Kelley
Thomas W. Kelley, Washington Post
H. Edward Kim, National Geographic
James Klebau
Paul N. Koenig III, NBC
Charles A. Kraft,
 U. S. News & World Report
Carl Kramer, Washington Post
Lawrence Krebs, WMAL
G. Bradford Kress, NBC
Emory K. Kristof, Jr.,
 National Geographic
Horace (Skip) Lambert,
 Phoenix Films, Inc.
John R. Langenegger, NBC
Carl Larsen, Jr., ABC
Bianca Lavies,
 National Geographic
Glen Leach, Washington Star
Dean Lee, Associated Press Photos
Warren K. Leffler,
 U. S. News & World Report
John Levy, NBC
Matthew Lewis, Washington Post
Arthur Lincer, UPI Newsfilm
Harold H. Lion
Bates W. Littlehales,
 National Geographic
Arthur V. Lodovichetti, ABC

John G. Long, NBC
Chester J. Lord
Bertrand J. Lureau, WMAL
Raymond Lustig, Jr.,
 Washington Star
Paul Lyons
Lewis C. Maddox, ABC
James Mahan
Lester Mannix
Cal A. Marlin, CBS
Fred J. Maroon
Gerald H. Martineau,
 Washington Post
Rosemary Martufi,
 Washington Star
Howard R. (Toby) Massey,
 Associated Press Photos
R. Norman Matheny,
 Christian Science Monitor
*Andrew J. May
John O. May, Hearst Metrotone News
O. Louis Mazzatenta,
 National Geographic
Tom L. McBride, Jr., WTTG
Robert McCormac, Jr.,
 UPI Newspictures
Ellen E. McDonnell
Loftus McDonough, NBC
William E. McDoughall, WMAL
Susan T. McElhinney, Newsweek
Lawrence McIntosh
James McNamara,
 Washington Post
Wallace McNamee, Newsweek
High Miller
Roddey E. Mims
Orlando Mingarelli
George Frederick Mobley,
 National Geographic
Robert Mole, NBC
Fred Montague, NBC
Donald T. Moore
Larry E. Morris, Washington Post
David L. Moubray, WTOP
John C. Mueller
Michael M. Murphy
Timothy A. Murphy,
 UPI Newspictures
Alfonso A. Muto

Harry N. Naltchayan,
 Washington Post
Joseph H. Neil
Arnold C. Noel,
 The White House
Bernard Norfolk
Richard V. Norling, NBC
Robert S. Oakes,
 National Geographic
Walter Oates, Washington Star
Richard O'Donnell, CBS
Alfred J. O'eth
Thomas J. O'Halloran, Jr.,
 U. S. News & World Report
Yoichi R. Okamoto
Norbert S. Olshefski,
 Washington Star
George G. H. Ortez,
 N.E.W.S. Photo-News Worldwide
Robert Otey
Allan S. Papkin, UPI Newspictures
James A. Parcell, Washington Post
Lee Parker, NBC
Winfield Parks, Jr.,
 National Geographic
Nicholas J. Pergola, UPI Newspictures
Robert F. Perkins
Robert J. Peterson, Jr.
Charles H. Phillips
James H. Pickerell
Ray Pippitt
Leo A. Pitts, WTOP
Steven Laurence Raymer,
 National Geographic
Burton K. Resnick, WTTG
James W. Rhodes, NBC
*Joseph B. Roberts
Elie S. Rogers
Henry W. Rohland
Clyde LeRoy Roller, WMAL
Byron H. Rollins,
 Associated Press Photos
George P. Romilly
Floyd Rose
Johnie F. Roth, Jr., WTOP
John H. Rons
Francis R. Routt, Washington Star
Randolph J. Routt, Washington Star

Arnold Sachs,
 Consolidated News Pictures
David Sampy, WRC
Ralph A. Santos, CBS
Joseph J. Scherschel,
 National Geographic
Paul A. Schmick, Washington Star
Paul M. Schmick
Frank Schreider
Jack Schultz, UPI Newsfilm
James J. Schultz
Arthur E. Scott,
 Senate Photo Historian
Michael Senko
Shepard Sherbell, Globe Photos
Jack Shere, American Red Cross
Charles E. Shutt,
 Hearst Metrotone News
Joseph A. Silverman,
 Washington Star
Paul C. Sisco, UPI Newsfilm
Robert F. Sisson,
 National Georgraphic
William J. Smith
William K. Smythe
Charles William Snead,
 Washington Post
Barry A. Sodrenko,
 Consolidated News Pictures
Maurice B. Sorrell,
 Johnson Publications
Jim Southerland, UPI Newspictures
George Sozio, NBC
James L. Stanfield,
 National Geographic
Don Carl Steffen
John W. Stein
Earl Joseph Steiner, ABC
Larry Stevens, Metro Group
B. Anthony Stewart,
 National Geographic
Richard H. Stewart
Alfred Story, NBC
Edward J. Streeky, Camera 5
Wellner C. Streets
Barry Edward Stroup,
 Associated Press Photos
James A. Sugar, National Geographic
Richard L. Swanson
Gordon Swenson

George Tames, New York Times
Charles B. Tasnadi,
 Associated Press Photos
Jeffrey Taylor,
 Associated Press Photos
Edward E. Thomas
Margaret Thomas,
 Washington Post
Ricardo P. Thomas,
 The White House
*F. Irving Thompson
Joseph J. Tomko, Jr.
Winston Townsend,
 Associated Press Photos
Stanley Tretick
Marion Trikosko,
 U. S. News & World Report
Coleman Reed Tuckson
Kazuo C. Uchima
Ronald W. Van Nostrand
Willard G. Volz, Washington Star
Daniel E. Vines, Jr., U.S.A.F.
C. A. Walker
Ralph E. Wallis
Fred Ward, Black Star
Murray E. Ward
Robert Webb, Washington Post
David Weigman, NBC
Jeffrey Weinstock
Jim Wells
Volkmar Wentzel,
 National Geographic
Hugo L. Wessels, UPI Newspictures
Ronald Weston
Linda Wheeler, Washington Post
F. Clyde Wilkinson
Malcolm Williams
William D. Wilson, Washington Star
Woodrow R. Wilson
Don Wingfield, Sporting News
Walter Wood
Wayne Charles Wood, WTTG
William H. Yates
Teresa Ann Zabala,
 New York Times

*Lifetime Members